PAINT EFFECTS

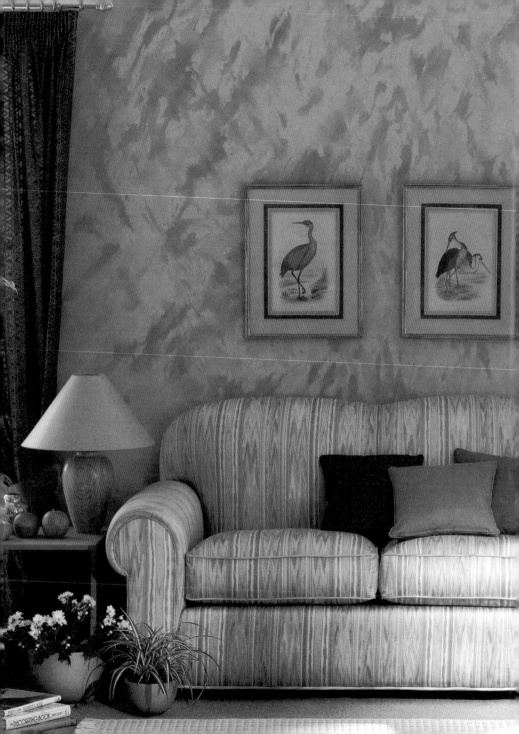

PAINT EFFECTS

A unique guide on how to use
decorative paint effects

AN OCEANA BOOK

First edition for North America published in 2003 by
Barron's Educational Series, Inc.

Copyright © 2003 Quantum Publishing Ltd.

All inquiries should be addressed to:
Barron's Educational Series, Inc.
250 Wireless Boulevard
Hauppauge, New York 11788
http://www.barronseduc.com

International Standard Book No. 0-7641-2433-1

Library of Congress Catalog Card No. 2002116527

This book is produced by
Oceana Books
6 Blundell Street
London N7 9BH

QUMEPE

Manufactured in Singapore by Pica Digital Pte Ltd.
Printed in Hong Kong by Paramount Printing Co. Ltd.

9 8 7 6 5 4 3 2 1

CONTENTS

7
INTRODUCTION

29
TECHNIQUES / EFFECTS

177
FLOORS

183
WALLS

191
FURNITURE

201
ACCESSORIES

209
GALLERY

220
GLOSSARY

222
INDEX

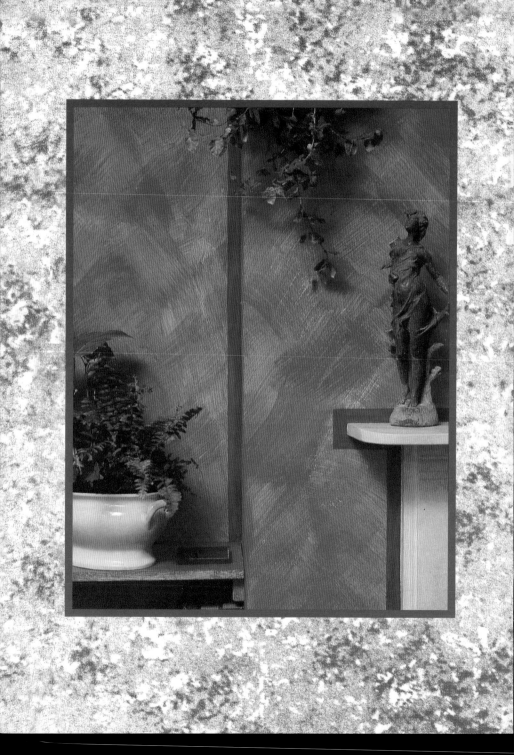

Introduction

Many people admire decorative paint effects, such as false marbling or woodgraining, but feel they could never achieve them without employing the assistance of a professional. Professional paint effect experts are often secretive and do everything in their power to maintain an air of mystery and secrecy. In truth, however, anyone with a little practice and determination can produce pleasing and successful results.

This book is written with the aim of making a range of paint effects accessible to everyone, from the more experienced decorator to the complete amateur who has never used a paintbrush before. If you are a beginner you will probably find techniques such as sponging easier than some of the more specialist effects such as gilding or *trompe l'oeil*, but don't be afraid to be adventurous. All the techniques described can be tackled by the amateur, provided you read the instructions carefully.

The modern decorator has access to a huge range of colors and textures. While it's true that decorative effects are more challenging than just applying a simple coat of gloss or emulsion, they are also more fun to do. And the results can transform a quite ordinary room into a very special and individual environment. So, be brave: the first step is always the most difficult but, once it's made, there will be no looking back.

TOOLS

The equipment you will require for each technique can be categorized under five separate headings from protecting and preparing the surrounds and surface, to the final finishing and cleaning up once the job is complete. By reading these next few sections carefully and noting the safety instructions for each piece of equipment (safe placement of ladders and so on), your own safety and that of your surroundings is ensured.

PREPARATION AND CLEANING *Before starting any job make sure that you are wearing some type of protective clothing appropriate to the job.*

1 Dust covers To protect all vulnerable areas or furniture or use plastic sheeting available from home improvement stores. This should prevent any accidental and possibly irreversible damage to the room and its contents. Old newspapers can be used as an alternative to sheeting but newsprint does not cover larger areas so easily and can leave marks.

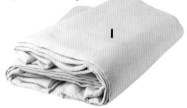

2 Synthetic cellulose sponge This is always good for wiping down the surface that you are preparing and is easily rinsed out.

3 Lint-free cloths These are cloths that will not shed their fibers during use. You will need them to wipe down and remove dust from any surfaces before you start work. They will also be used to dampen in the relevant solvent, and to remove quickly any mistakes or mishaps that may occur in the course of applying the technique.

4 "Tack cloth" This is cloth impregnated with linseed oil. It will free the surface of any dust particles safely and completely.

5 Bucket of fresh water This is a good idea to have nearby as it can be used to clean up any accidents that may occur when you are using water-based or oil-based products, as well as removing any splashes to your skin or eyes or clothes.

PREPARING SURFACES *For any technique to be completed easily and professionally, thorough preparation is essential. This part of a project is not very exciting, but it must always be done really well to ensure an excellent result, and also to prevent any chance of unwanted reactions between stages that will spoil your final effect.*

1 Cleaner or a proprietary degreasing agent (sugar soap)
This type of cleaner should be applied to the surface before you start work. Rinse thoroughly afterward.

2 Sandpaper Existing paint or varnish must be removed completely or at least any flaking sections removed. You should stock various grades of sandpaper for different tasks.

3 Sanding block This will make the job of sanding larger areas a great deal easier as equal pressure is applied over the surface of the flat block.

4 Steel wool Available in various grades can also be used to "key" the surface before you start to paint and this will also help to remove any flaky paint or varnish.

5 Scrapers These are another essential tool for both stripping off paint and varnish (when using proprietary stripping products), and for eliminating larger flaking areas. They are also ideally suited for filling any cracks and holes when using store-bought fillers.

6 Wire brushes Depending on the type of surface and its condition, wire brushes (both stiff and fine) are also ideal for preparing the surface as well as removing any rust and so on, from metallic surfaces.

GENERAL EQUIPMENT

1 Ladder This is an essential piece of equipment if you are doing a ceiling, wall or picture rail. For most average rooms this would be a 3- to 4- step ladder. These are available from most general stores. A lightweight aluminium ladder is most suitable as they are strong yet easily portable. When using ladders make sure that they are placed securely before climbing.

2 Masking tape Used to mask off areas which need to be protected from the paint finish being applied. Also used to create stripes and for creating perfectly straight lines. Low-tack is best.

3 Brown paper tape A self-adhesive strip along one side makes this tape useful for protecting ceilings and corners as well as carpet edges.

4 Natural or marine sponges Necessary for the sponging technique and which can also be used for stenciling, texturing surfaces, and for breaking up glazes.

5 Sharp scissors, craft knife or scalpel Essential when applying *découpage*, but also for creating stencils and for cutting straight edges.

6 Quality steel tape measure Important for precise measuring (available in both U.S. and metric and in most cases both).

7 Pencils For accurate measurement and for achieving fine straight edges as in stripes. Remember that pencil marks are harder to remove than chalk and can damage the surface. They are ideal when masking tape is used and they can be painted over as part of the technique.

8 Chalk Used for drawing in lines. Chalk is easily removed and will not mark the surface.

9 Straight edge or steel ruler Required for lining and obtaining accurate lines.

10 Plumb-bob or plumbline
Essential for obtaining perfect vertical lines.

11 Buckets
A range of suitably-sized buckets for washing brushes in or for mixing paints (this may include old plastic containers such as those used for ice cream). A paint kettle allows you to use a small amount of paint at one time, keeping the remainder clean and protected from air (which causes a skin to form).

12 Palettes
Are used for mixing small amounts of paint or glaze, and can also be used for resting brushes. Use a white palette for mixing transparent colors and a light brown palette for opaque colors.

13 Paint tray and roller
As an alternative to brushes. makes painting larger areas easier and quicker.

14 Paint can opener or a flat-head screwdriver
For opening paint cans. Do not use keys or a coin as this can cause accidents as the grip pressure is not correct.

15 Paper (kitchen) towel, cotton rags
For cleaning up and wiping down drips etc., from the paint cans.

16 Mutton cloth
A variable-weave cloth used for cleaning up and creating various paint effects.

10

11

16

14

15

BRUSHES

The secret of success when applying paint techniques is controlled by the use of the correct or best brush for the particular finish being applied. Is it the correct size for the job? Will it easily reach into corners or produce a straight edge if required? Will it produce a fine line?

A good basic rule when choosing brushes is to go for the best brush you can afford for the particular job. It will pay for itself in the end, especially if it is cared for correctly! Remember also that brushes are composed of different materials. Nylon or synthetic brushes are generally for use with water-based paints while the oil-based paints are generally used with bristle or hair brushes.

Some brushes, especially those made of natural bristle, can be expensive, but they are well worth the outlay! Stippling brushes and badger hair softening brushes can be extremely expensive, and although cheaper alternatives can be used it is not advisable. Always buy the best quality you can afford to ensure quality results.

TYPES OF BRUSHES

1 Bristle basecoat brushes come in a wide range of different sizes. For priming and undercoating it is best to use a straight-edge brush and for cutting in edges, a chisel-edge brush. Choose the size that is most suitable to the job – the largest that you feel comfortable with. A good range to purchase would be ½ in. (1.3 cm), 1 in. (2.5 cm), 2 in. (5 cm), 4 in. (10 cm) or 5 in. (12.5 cm).

2 Softening brushes such as the high quality, badger hair softener are very expensive. A hog hair softener or dusting brush is a cheaper alternative but its primary use is to remove excess dust before you start painting.

3 Dragging brushes are long-bristled brushes that are used for the dragging and graining techniques. An alternative would be an ordinary base-coat brush but the effect is less subtle.

4 Sponge applicators are ideal for small areas as they show no brush strokes. They are excellent for cutting in on panels and for working in tight corners.

5 Lining brushes e.g. sword liners, are an essential tool for line and other decorative applications. They hold the paint in long bristles and allow easy flow. They are also ideal for marbling. Good after care is essential as with all these brushes. Build up a collection starting with sizes 0, 1, and 3.

11

6 Fitch brushes are usually made of hog hair and come in shapes such as round, oval, or flat, and can be chiseled or flat. They are well suited to cutting in and for applying primary veins when marbling etc. Start with $^1/_4$–$^1/_2$ in. (0.63–1.3 cm) round and $^1/_2$ in. (1.3 cm) flat, and possibly a $^1/_2$–$^3/_4$ in. (1.3–1.9 cm) chiseled.

7 Varnishing brushes come in a wide range of sizes. They are thickly bristled and can be flat or domed. Ideally purchase a 2 in. (5 cm) flat brush.

8 Mottling brushes come in squirrel or hog hair and are used in graining techniques. A good starter would be a 2 in. (5 cm) brush.

9 Stenciling brushes come flat or domed and in many sizes. Flat brushes work well when a stippling motion is used. The domed variety are good for soft, exquisite shading. Begin with a $^1/_2$ in. (1.3 cm) flat and a $^1/_2$–$^3/_4$ in. (1.3–1.9 cm) domed.

8

10 Toothbrushes are excellent for use in spattering techniques. Good stiff bristles help to control the paint flow.

11 Stippling brushes come in a variety of shapes and sizes that produce different textural effects. They can be made of bristle or rubber and this dictates the price.

5

6

Care of Brushes

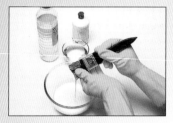

CLEANING *Oil-based paint: Use two containers of solvent and wear protective gloves. Dip brush in and work out paint from ferrule downward until clean. Use second container of clean solvent and repeat. Wash brush in detergent and rinse in fresh water. Water-based paint: Use same technique as above removing paint under running water. Apply soap and rinse.*

DRYING *Carefully squeeze along bristles from ferrule down with your finger to remove moisture. Do not work up or against bristles as it can cause damage.*

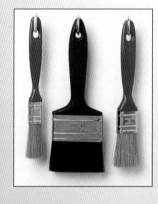

STORING *Hang brushes, bristles down, from a suitable hook or stand them upright in clear containers. Do not overcrowd as this will damage the bristles.*

PREPARATION

The final result of any decorative technique will depend on the quality of the preparation work. Unfortunately most of us find this a nuisance, but hard work and dedication at this stage will only lead to a successful final finish. Some techniques do benefit from a less than smooth surface, color washing in particular, but this does not apply to most of the broken color work techniques.

Neatness and keeping the work surface and surrounding areas clean and clear is essential. Make lists of all the tools and materials needed, and use only those that are required. Remove any unnecessary items from the area, including furniture if possible. Make sure you understand the technique and the products that you are going to be using before you start. Good preparation will save time and will eliminate costly and unnecessary mistakes.

CLEANING *It is important that the surface to be painted is cleaned thoroughly before any work is done. Grease should be treated with either a degreasing agent (sugar soap) or similar cleaner following manufacturer's instructions. All dust and stray particles should be removed with a dusting brush or tack cloth and any excess vacuumed away completely before the job is started. This is crucial as dust will be blown around and may affect the wet paint surface. Wash the surface with clean water and allow to dry completely before beginning the work.*

THE USE OF STRIPPERS

All existing paint should be removed from the surface before beginning the work. If the surface is in good condition then sanding will be adequate. Begin by using coarse grade sandpaper. A sanding block will help. Fold the sandpaper to get into moldings. Rough paint or varnish should be removed completely with chemical strippers and a scraper, following manufacturer's instructions. A gel stripper is easier to use than liquid caustic soda.

Wear a protective mask and goggles when applying chemical strippers to any surface.

CHEMICAL STRIPPERS

When using store-bought chemical strippers always wear adequate protective clothing, including acid-repellant gloves. Always work carefully and be sure that you do not splash yourself or damage any other surface.

DEGREASING

1 Ready-prepared degreasing agents such as sugar soap, should be used with care following manufacturer's instructions. These agents are ideal for cleaning or distressing surfaces prior to painting.

2 Always wear protective clothing and rubber gloves. After each application clean down the surface with water. Steel wool can be used in combination with a degreaser for particularly difficult jobs.

GENERAL CLEANING

For cleaning down surfaces such as cupboards and cabinets, a kitchen scouring pad is as good as anything. If using toxic materials always wear adequate protection.

PREPARING A WALL *The type of effect required will determine the exact preparation necessary to a wall, but whatever you are doing, old wallpaper should be removed completely and any cracks filled with filler and, when dry, sanded to a smooth finish. An undercoat or primer should be applied to seal the surface before base coating. Paint quick drying shellac (knotting solution) over any newly-filled cracks to avoid color imperfection when applying the base coat. If the walls are very damaged, apply lining paper before priming and base coating. Ensure that new bare plaster is absolutely dry before applying paint to it. Water trapped in the plaster weakens the adhesion of the paint and may cause blistering. Some plasters have an alkaline nature, and when the plaster dries, white fluffy alkaline crystals may be deposited on the surface. These should be removed with a dry brush before painting. If you have stripped off wallpaper, it is important to remove any trace of paste or size remaining on the surface, because these can cause the newly applied paint to flake. Wash the wall with warm water and sugar soap.*

FILLING CRACKS

When filling cracks in walls use a good quality filler and always follow manufacturer's instructions. Carefully fill the entire crack pushing the filler in with a trowel. Remember to leave a little excess on the surface to allow for shrinkage when drying. Sand smooth.

SAFETY FIRST

Always wear suitable protective clothing when carrying out any surface preparation. When sanding down surfaces it may be necessary to use a face mask to avoid any danger from the inhalation of fine dust.

SKIMMING *Certain techniques that require an extremely smooth surface, such as lacquering and marbling, may mean that skimming is necessary after priming. This is done with skimming plaster (spackle) and is extremely difficult to perfect. Using a skimming blade, pass the plaster across the surface filling all indentations. Use even, smooth movements. Wipe the blade clean and pass again over the surface. Slightly dampen the blade if necessary. Depending on the size and condition of the wall, it may be better to call in a professional plasterer to do this.*

PREPARING METAL *When preparing a metal surface, it is important that all rust is removed using steel wool or, if the rust is particularly bad, a wire brush followed by steel wool. Once sanded, remove all traces of dust before applying a coat of de-rusting solution (follow all safety guides). Allow to dry completely before applying at least one coat of metal primer. When dry, apply two or three coats of an oil-based paint such as eggshell in a base-coat color. You are now ready to continue with the paint effect. For small metal objects, you may find it easier to use spray paint. New metal may have a greasy layer to protect it from rust and this should be washed off with detergent.*

CLEANING

When painting metal, particularly old or rusty metal, always use adequate protection. With a stiff wire brush carefully remove all loose paint and rust from the surface before brushing away excess with a soft cloth.

SANDING METAL

Use a coarse grade sandpaper and work down to a fine grade sandpaper. Completely sand off any remaining rust or paint making sure not to miss any awkward areas. Wipe away any excess dust using a soft cloth.

APPLYING RUST REMOVER

Use a bristle brush to apply a coat of rust remover or inhibitor, following manufacturer's instructions, and allow to dry completely. These products form a protective film over the surface which inhibits any further oxidation.

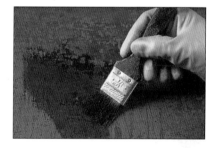

UNDERCOATING WITH RED OXIDE

With a bristle brush apply an undercoat of sealant such as red oxide. This will seal the surface and also provide a good base for applying your your chosen base coat. Apply two layers of the base coat.

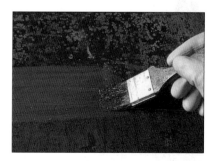

PREPARING WOOD *The preparation depends on the final look required, a weathered look requires possibly the least amount of preparation. Remove all nails and fill and sand all holes before priming, undercoating, and base coating. Always sand between coats. Raw wood containing knots should be sealed with a knotting solution or shellac (to avoid the chance of resin staining the paint work) before being primed or undercoated and base coated. Again, sand between coats to obtain a really smooth surface. Remove all traces of dust with a tack cloth before continuing. Reprime if the surface is still uneven and apply a second base coat.*

REMOVING EXCESS PAINT AND VARNISH

When treating old surfaces that have seen a lot of wear and tear, remove any excess flaking paint or varnish with a good, sharp scraping tool. Be careful not to gouge the surface as you work. Always work with the grain, not against or across it.

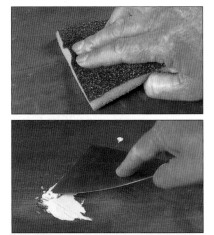

REMOVING NAILS AND FILLING

When preparing surfaces, using the correct tools for the job helps to avoid accidents and makes the job easier. Use pincers to carefully and safely remove nails and other unwanted items from the surface.

ROUGH SANDING

Once the nails have been removed, sand the surface gently to remove any excess splinters. This will also prepare the surface for filling.

FILLING

Any holes should be overfilled with store-bought filler. This is to allow for shrinkage during the drying process. Smooth the filling paste out as much as possible but still leave a little excess.

SANDING

To obtain a smooth finish, use different grades of sandpaper, from coarse to fine. Always finish with a fine grade sandpaper. The use of a sanding block helps to achieve an ultra-smooth finish.

PAINTS

*T*he techniques described in this book use a variety of paints, both oil- and water-based depending on the finish required. Paints such as acrylic eggshell are now much more user-friendly. However, always read all the manufacturer's information about use and content before you buy. Water-based paints such as latex (vinyl silk emulsion) and simulated milk paint, are more eco-friendly and can be cleaned off brushes with water instead of turpentine or mineral spirits (white spirit). However, each type of paint has its own merits and for this reason specific paints have been chosen specially for each technique.

TYPES OF PAINTS

Oil-based undercoat is available as an undercoat and primer combined. It is used before applying a base coat, especially on raw wood (depending on technique). It is now available with no added lead.

Oil-based eggshell paint is mainly used for woodwork and walls. It is slow drying and gives a wipeable mid-sheen finish. It is particularly good for covering color surfaces. When working with this paint be sure there is adequate ventilation.

Oil-based gloss paint is used as a finishing coat on woodwork. Unsuitable for use with paint effect work.

Latex (Vinyl silk emulsion) is an ideal base for walls to be given a decorative paint finish. A vast range of colors is available and it is quick drying. It gives excellent coverage but is easily damaged.

Water-based acrylic eggshell paint is a user-friendly version of oil-based eggshell. It gives good coverage.

1 Artists' acrylic paints are available in strong colors and are ideal for tinting water-based glazes used for broken color effects.

2 Artists' oil colors are used for tinting oil glazes for broken color work and oil-based marbling effects, but can be expensive.

3 Powder pigments are used for tinting glazes and paints and give intense color.

4 Pigment syringe available from DIY stores, is used for tinting paints.

5 Simulated milk paint has a very soft, flat finish similar to limewash, and gives a "dusty" appearance. It is water soluble. It will need an additional protective coat if it is to be subject to a lot of wear and tear. Excellent for use on furniture and walls.

6 Water-based dyes are eco-friendly and are excellent for wood-staining and color washing. They do need varnishing.

7 Stencil paints come in a good color range, are quick drying and can be used for tinting acrylic glaze.

Metallic paints are for interior and exterior use. Water-based paints will need two to three coats. The spirit-based and lacquer-based paints dry very quickly.

Woodstain highlights the grain of wood and is available in either spirit- or water-based versions. Plain woodstains are available, as well as a range of colors.

RULES FOR MIXING PAINT *Paint can be mixed mechanically at your local home improvement store. But although there is a vast range of colors to choose from, you may not find the exact shade you want. By buying the closest colors and other tinting agents, you can achieve the shade you require. Always make sure that the solvent base in both paint and tinting agent is the* same. *When tinting or mixing add a little color at a time and stir thoroughly. You may find it easier to dilute the tinting agent with a little of the relevant solvent first as this will help to achieve an even color. Always mix enough paint to complete the job as matching will be almost impossible.*

Color

Color mixing depends a great deal on getting to know the individual hues and how they react with one another. The color wheel is a way of showing colors' foremost characteristics. Color creates moods, it can change the whole ambience of a setting – even the same color used as a solid block or as broken color effect will vary immensely. Light from different sources will also change a color quite noticeably. When a color is used in conjunction with others it can easily change – blues can become gray or mauve, greens can become yellow or shades of blue. Different people view particular colors in very different and individual ways. A particular color scheme that works for one person may not work at all for another. Pursue your own ideas and do not be led by fashion trends or the opinions of friends and neighbors.

THE USE OF TONE By varying the intensity of a pure color or "hue" we obtain a tone of that color which is lighter or darker. Some people find "pure" colors too over-powering: they find it easier to live with a tone. Tone is the lightness or darkness of a pure color. By adding white to a tone you obtain a tint, and by adding black you obtain a shade. A green or a blue or a red may all have the same tonal value if the same amount of white or black is added. When planning a color scheme it is easier to coordinate colors of the same tonal value unless you want to create a particularly vibrant and powerful look.

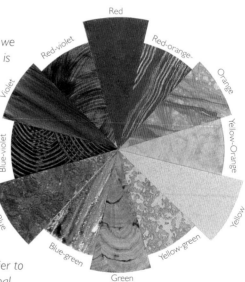

THE COLOR WHEEL Discovered by Sir Isaac Newton in the 7th century, the color wheel comprises 12 colors. The primary colors are red, yellow and blue. The three secondary colors are formed by mixing equal parts of the three primaries for example, green (yellow and blue), violet (red and blue) and orange (red and yellow). Lastly there are the tertiary colors, which are obtained by mixing primary color with its closest secondary. This mixing results in the six tertiary colors, orange and red, violet and blue, violet and red, green and yellow, yellow and orange, and blue and green.

HOW COLOR AFFECTS A ROOM *The classification of colors into warm and cool does not necessarily stand true. Generally reds, yellows, and oranges are classified as warm colors, and blues, greens, and grays as cool. But there are warm blues, which contain more red, and also cool yellows which contain more green. Two blues together can be seen as both cool and warm.*

As a general rule, warm colors will make a room seem smaller, whereas cool colors will give a more spacious feel. For example, a pale lemon will create a very soothing, airy, and open feeling, whereas a dull yellow, although warm and vibrant, will reduce the apparent size of the room.

The amount of proportion of color used in a room, together with its position, will also affect both mood and space. Darker ceilings will substantially reduce a room's height, and dark walls will close them in, making the room more intimate. Dark color above a dado rail with light color below will reduce the height of the ceiling and may cause the overall effect to seem a little top heavy. By using the darker color below the dado, although it will "enclose" the room the lighter top walls and ceiling will give a feeling of the room being open and airy.

The use of two cool and light colors can create a feeling of spaciousness.

Using two warm colors together can create an intimate atmosphere.

A dark color above a dado rail can make a room look a little top heavy.

Dark colors below a dado rail enclose a room, light colors above give balance.

FINISHING

A great deal of love and hard work goes into all broken paintwork techniques and to spoil them at this or a later stage would be a shame. Certain techniques need protection for a variety of reasons, but notably for general wear and tear such as susceptibility to the elements, or the fact that they may be exposed to steam or water as in bathrooms and kitchens. Floors will need to be particularly hard wearing and therefore suitably protected. Gilding with metal leaf is prone to tarnishing and should be sealed. Techniques such as faux marble, malachite, and steel need the final varnishing as an integral part of the technique. This gives the surface a highly polished finish that is characteristic. However there are certain finishing techniques that do not benefit from or need any final protection.

AVAILABLE PROTECTIVE FINISHES

1 Oil-based varnish Many products are available on the market and they are always changing and improving. Oil varnish is more sturdy than its water-based equivalent. Most oil-based varnishes tend to yellow in sunlight or are naturally slightly tinted so always check before you use them as they can damage the coloration of a finish quite noticeably. Polyurethane tends to be the most popular, but it is quite yellow and can be brittle. It is available in three finishes: flat, satin, and gloss.

2 Spray varnishes These are nonyellowing and and they need to be treated with great care. They tend to offer only limited protection and work better on water-based effects. They are available in matte and gloss finishes.

3 Shellac/knotting solution This provides a barrier between the wood knots and the painted finish. It stops the resin in the wood from bleeding through and discoloring the paint. It is not resistant to water or alcohol.

4 Water-based varnishes The acrylic or resin-based varnishes do not yellow, are reasonably heat and water resistant, and more user friendly. Finishes available are flat and satin.

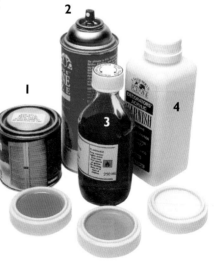

THE VARNISHING PROCEDURE *Correct preparation is extremely important when applying varnish, and an extremely clean, dust and lint-free area is vital. The ease of application is increased by warmth, so a warm constant temperature to work in is best. Check that the surface is free from grease before you start. Use a tack cloth to remove any stray dust. Stir the varnish well and decant enough varnish slowly into a clean container. Then load the brush carefully and wipe off any excess. Pass the brush once over a clean, dry board or a piece of greaseproof paper to help remove any air that is contained within the varnish. If the varnish is too thick, dilute it a little with the relevant solvent. You are now ready to proceed.*

2 Using wet-and-dry sandpaper, smooth down surface after dipping paper in a little water. Do this gently so surface is not damaged. Wet-and-dry sandpaper is excellent for rubbing down paint as it is gentle and gives a smooth finish.

3 Wash the surface with clean water and a soft cloth when you have completed the area. Allow to dry completely and reuse the tack cloth.

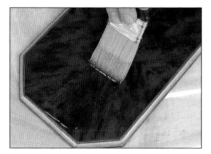

1 Brush on the varnish in clean strokes across the whole surface in one direction, holding the brush at a slight angle to the surface. Once you have finished, and with your brush free of varnish, gently remove the brush strokes. Dry. Apply a second coat in the same way.

4 Apply another coat of varnish repeating steps 1 to 3. Let dry and then continue as necessary until you apply the final layer of varnish which should result in a mirror-like finish.

WAXES *The best are furniture waxes that come in a soft form and in varying colorways, although they can be tinted with stainers or powder color. When they are applied with 0000 grade steel wool and carefully buffed up, they produce a delightful soft sheen. Wax should not be applied to glossy surfaces, such as plastic, and is used as the final protection for some techniques. It must be removed before starting any technique as it creates a barrier that will not take paint.*

WAXING *Wax is always the final finish whether it is natural beeswax, tinted furniture wax, or gilding wax. Additional decorative layers of paint will not take over wax finishes so remember to complete all your detail and final work before applying the wax finish. Try to avoid the use of spray silicone waxes, they tend to smear and can be less protective than their paste counterparts.*

When you have completed the ceiling, walls, and floors of the room it is time to apply your chosen technique to the coving, ceiling rosette (rose), pilasters, and corbels. This is done more easily before they are fixed into position. Once dry, and the relevant protection has been applied, carefully fix them in place. Begin with the coving, followed by the ceiling rosette (rose) and then any pilasters, corbels, or panel moldings and lastly dado rails. Finally, touch up any damage with fresh fixing plaster and paint.

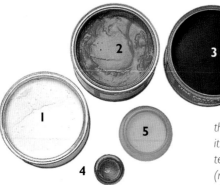

1 Liming wax works best on open-grained woods.

2 Clear wax gives final protection for furniture creating a warm, soft sheen.

3 Antiquing wax is used over paint effects to create a mellow antique look. Golden brown is the most popular color.

4 Gilding wax is mainly used for high-lighting moldings and edges.

5 Beeswax is a traditional wax for protecting oak and pine against dryness.

GLAZES *A water-based glaze or PVA (polyvinyl acetate) medium is a polymer emulsion that may be diluted with water. When allowed to dry, it forms a clear transparent film that is extremely resistant to yellowing. These glazes must be tinted with a good quality water-soluble pigment. Emulsion glaze can be mixed with a colored emulsion or latex paint to match a scheme or design, but the opaque mix will flatten the effect.*

Emulsion glazes are extremely useful, retaining the benefits of transparency without the difficulties of yellowing. When dry they are water-resistant, and they are available in matte, satin, and gloss finishes. The fact that they are water based eases the problem of cleaning brushes and equipment, but means that drying times are not long enough for some finishes to be achieved with them.

GLAZING MEDIUMS

I Transparent oil glaze used for oil-based paint effect glazing. Gives more working time but tends to yellow with age. Dilute glaze with mineral spirits (white spirit). Add tint with oil colors or universal stainers.

2 Acrylic glazing medium is non-yellowing and water and heat-resistant. It is tinted with acrylic colors for decorative glaze work. It gives a short working time, about 15–30 minutes.

3 Gilp is used as the floating medium for marbling. Mix together 1 part boiled linseed oil, 1 part pure mineral spirits (turpentine or white spirit), and 1/20th japan drier. Store in an airtight container.

MAKING YOUR OWN GLAZE

If you can't find ready-mixed oil glaze and you're at home "baking from scratch," you can make your own glaze with ingredients found in most art supply stores or mail order art supply catalogues. The glaze, however, will dry slower and smell stronger.

To make the glaze, mix three parts turpentine to one part boiled linseed oil. (Linseed oil comes either boiled or raw; boiled is thicker and dries faster.) Then add a few drops of cobalt drier or japan drier, and color your glaze with paint or tints.

Techniques and Effects

In this section of the book many of the techniques can be achieved with the minimum amount of time and with a basic understanding of the technical aspects and the physical properties of the paint and glazes. They are effects that produce excellent results when applied by both the professional and the amateur decorator. Once the basics have been mastered you will feel more confident about moving on to more advanced levels of broken paintwork. As you proceed the possibilities become endless and you will find yourself becoming more and more adventurous.

The finishes described in this section have been simplified as much as possible to reduce decorating costs and increase ease of application. As you become more experienced, you may want to move on to more difficult and complicated techniques. One of the exciting aspects of decorative paint effects is that there are always different ways of achieving effects and, no matter how long you've been graining or marbling, there will always be new tricks and shortcuts to learn.

COLOR WASHING

Many areas of the home, such as walls, ceiling rosettes, pilasters, and corbels, lend themselves to color-washing, as do kitchen cabinets, tables and small decorative pieces, including boxes and lamp bases. Being such a versatile effect, it works well in its own right as well as with other effects, such as stencilling, stripes and mosaic.

When choosing a color, the complete palette is open to you, depending on the finished look required. For richness, dark reds and burgundies work well over cream or yellow ocher. For a more subtle effect, yellow ocher over magnolia creates warmth and is very light and airy. For the best results, colorwashing should be done with glazes over a semigloss (silk) finish base coat. An average room can be very successfully color washed in one or two days with the minimum of practice.

By using a sample board, color and technique can be finalized without making mistakes. The most common mistakes are caused by trying to work on too big an area at one time. It is necessary when working on one area to leave a "wet edge" that will merge with the next area while it is still wet. An absorbent base coat can also cause problems, so follow all the manufacturer's instructions carefully.

COLOR WASH ON WALLS

Color washing on walls can create very diverse results – from the sophisticated to the casual and from the very elegant to the most simple of country looks.

I Apply the glaze lightly with a standard decorating brush. Vary the angle and direction of the brush, allowing the ground to show through.

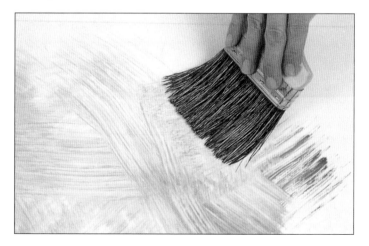

2 Allow to dry. The brush marks, which are clearly apparent, criss-cross unevenly over the surface.

3 Using the same glaze and brush, apply the second coat. Try to make the brush strokes cross those underneath.

4 The completed effect is an undulating finish with a refreshing crispness.

COLOR WASH ON WOOD

You can color wash wood with thinned-down emulsion or latex, which is slightly opaque, or use a true transparent wash, consisting of pure color – watercolor, gouache, or a powdered pigments – suspended in water. But you need to take certain precautions first.

When raw wood is dampened with a water-based medium, its sponge-like reactions lead to the rising of the grain. If you want a soft effect, it is wise to dampen down the surface of the wood first with a clean, damp cloth. When the wood is dry, flatten the raised grain with a fine abrasive paper and block

before proceeding.

If you are color washing a piece of furniture that has been stripped to its raw state, neutralize the surface by washing it down with a mixture of one part vinegar to twenty parts water.

A piece made from raw new timber needs to be checked for any filled areas. These will not be porous, and will therefore refuse to take the color. You can touch in small, unobtrusive fillings with color later. But if the filling is extensive, you may have to consider a different effect.

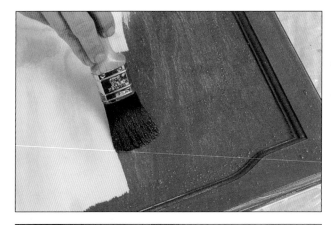

COLOR WASH ON WOOD
1 Apply the thinned color quickly to cover the area without patches.

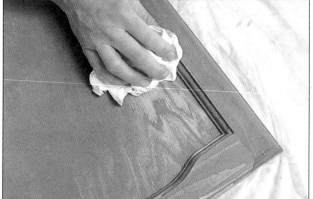

2 Rub over the surface with an absorbent cloth to remove the excess wash.

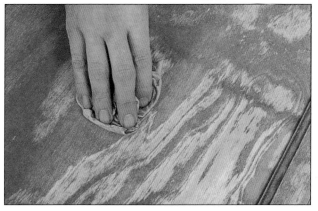

3 Use a damp cloth to clean up any remaining surface color.

VARIATION 1 *A very effective paneled effect can be achieved by simply masking off one section of the surface at a time with low-tack masking tape, and applying stippling and color washing. Here the chosen glaze color was pale blue used over a base coat of mid-gray, resulting in a subdued and ethereal look.*

VARIATION 2 *Brush strokes are part of the essence of color washing and need not be removed. They can create a totally characteristic look, whether it be in a rural or urban setting. Here, the base coat of lemon yellow has been enhanced by the use of a pale blue glaze, with accentuated brush strokes.*

VARIATION 3 *Here the buff-color base coat of semigloss latex (vinyl silk emulsion) was color washed with a very pale yellow ocher latex (emulsion), mixed with a little acrylic glazing medium. The brushstrokes were left and the glaze applied more heavily around the edges. When dry (24 hours) another glaze of dusty rose was applied using crisscross brush strokes.*

SPATTERING

Spattering is a technique that allows your imagination to run riot as far as color choice is concerned. Bold color will create a vibrant setting whereas subtle color can look very sophisticated and stylish.

It is a paint effect that is ideally suited to furniture, table tops, and paneling, and it also looks very good on small objects such as lamp bases, picture and mirror frames, and bowls. Larger areas can be a problem because spattering creates a very variable effect. However, as you gain in confidence and experience, this can be overcome.

Spattering is inexpensive to achieve as the humble toothbrush can be substituted for the stiff-bristled decorator brush and will do just as good a job.

Problems may arise in obtaining evenness of color, especially over large areas. But this can be overcome by lots of practice. Ideally the paint should be a thick-cream consistency, allowing "flow" and thereby eliminating unsightly blobs and splotches. A nonabsorbent base coat enables any of these blemishes to be quickly wiped off with a soft cloth and carefully reapplied.

MULTICOLORED SPATTER ON A DRY GROUND

1 Mix the color with the appropriate thinner to the consistency of milk.

2 Lightly load the brush, and hold it so that the color runs to the ends of the bristles and not toward the stock. Slowly pull your finger over the ends of the bristles, so that small spots of color are propelled onto the surface.

3 Once the spatter is dry, you can apply a second color, in this case gold.

4 The completed effect has a feeling of depth, and the gold dots glint like tiny sequins.

SPATTER ON A WET GROUND

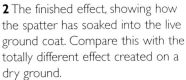

1 Apply the ground coat by brush or roller. Spatter the thinned glaze, following the same method as for the dry ground. Because the ground is wet, the spatter is less likely to run.

2 The finished effect, showing how the spatter has soaked into the live ground coat. Compare this with the totally different effect created on a dry ground.

SPATTERING A CEILING ROSETTE

This speckled effect can be used on virtually all surfaces. It is ideal for lamp bases, tables, ceiling roses and even smaller items of furniture. You can also use it to create the appearance of granite or stone.

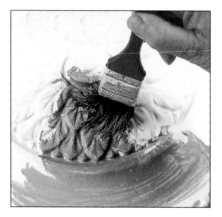

2 Paint the surface with the pale blue base coat using the bristle base coat brush. Make sure the paint covers any awkward areas and that there is no paint build up in the recessed areas.

I Prepare the surface, making sure it is dry. Apply the undercoat with the bristle base coat brush. Allow to dry.

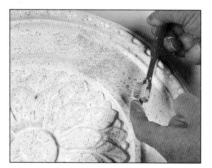

3 In a clean dish mix the mid-blue paint with water until it is a pouring consistency. Using a toothbrush, spatter the surface with an even spray of the mid-blue paint. Allow this to dry.

4 Dilute the deep blue paint with water until it is a pouring consistency. Once again, spatter the surface evenly using a toothbrush.

5 The choice of three shades of blue to spatter the surface of this ceiling rosette has created a defined yet subdued finish that is full of depth. The effect of spattering is spontaneous and relies entirely upon your own personal taste – opening up endless possibilities for both design and color.

VARIATION 1 *For this example an oil glaze of deep blue has been stippled over a basecoat of yellow ocher, and the surface carefully spattered with mineral spirits. After drying, acrylic paint was spattered on with a toothbrush, using white followed by emerald green, to create a three-dimensional look.*

VARIATION 2 *By using a diffuser available from good art supply stores, the base coat of deep pink has been more evenly spattered with mid-green, allowed to dry, and then, extremely carefully, spattered again using a pale cream. By choosing colors similar in shade, elegant results can be achieved with the diffuser.*

SPONGING

S ponging is a striking effect, enhanced by the use of two or more colors, and is simple to achieve. Ideally suited to any flat surface, including walls, ceilings, floors, furniture and fitted cabinets, sponging also works well on small, decorative items such as lamp bases, boxes and picture frames. Heavily carved items should be avoided. Although the quality of the surface preparation is always important, sponging tends to cover a multitude of sins and disguises minor flaws and cracks in the surface most effectively, particularly when a combination or one or two colors is involved.

Good results are quick and easy to achieve with sponging, with only a little practice, so that even the most daunting of rooms can be completed within a day or so. Once you have decided on your choice of colors, it is always advisable to do a sample board. A common mistake is to use colors that, when applied over the top of each other, tend to merge into a rather "muddy" look. It can also be tempting to use too much paint on the sponge, so by practice you will learn to control the amount of paint and eliminate the chance of unsightly smudges that will destroy the overall effect.

A common mistake is to create a pattern that is too formal, this can be avoided by constantly turning the sponge during application. If mistakes do occur, you can either remove the offending area immediately with a soft cloth, or allow the sponged area to dry and responge over the top with the base color.

The related effect of sponging off is achieved by painting the ground with a glaze, stippling out the brush strokes and flaws, and then removing the glaze with a clean sponge. The sponge is dabbed onto the surface and removed quickly. You need to wash the sponge frequently to prevent the build up of glaze.

SPONGING IN A RELAXED INFORMAL SETTING: Sponging, like so many paint effect techniques, is very versatile. Here the extremely open nature of the effect together with the use of both dark and light blues, has successfully created a very tactile look – the large wall areas have been given an additional dimension.

SPONGING ON

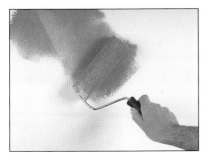

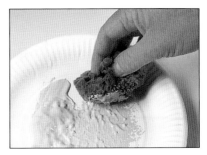

I Prepare the surface by completing any major repairs. Apply an under-coat and allow it to dry. Apply two base coats of mid-blue vinyl silk latex paint with a sponge paint roller or a 3–4 in. (7.5–10 cm) bristle base coat brush. Allow to dry between each coat and before commencing the next step.

2 Pour a little lilac vinyl silk emulsion into a clean dish (if mixing a certain color, mix enough to complete the job). Dip the sponge into some clean water and squeeze out the excess. Dab the damp sponge into the lilac paint. Do not overfill the sponge, as a little goes a long way. Remove the excess paint from the sponge by dabbing it on the side of the dish or on some clean paper towel.

3 Slowly and carefully touch the wall surface with the sponge, being careful not to apply too much pressure (this will cause unsightly splotches). Gently and smoothly remove the sponge and reapply to a fresh area. Gradually turn the sponge as you work to vary the imprint pattern. Reapply a small amount of paint to the sponge, removing excess as necessary. Each loading of the sponge should last for about 8–10 imprints.

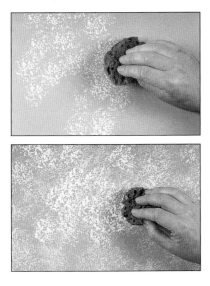

4 Repeat step 3 using a clean sponge and a vinyl silk emulsion in pale green. Sponge the entire surface with the green as before, or, to create a more uneven effect, use the green randomly over the surface.

SPONGING ON (continued)

5 Sponging is a technique that is easily done, and is limited only by your imagination. The qualities of the natural (marine) sponge enhance the two-dimensional surface as well as disguising any flaws that it may have.

SPONGING OFF

This is a subtracted effect normally achieved with oil, although water-based glazes can be used over small areas. The completed effect should be a fine undulating finish with subtle movement and depth.

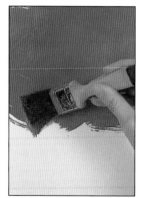

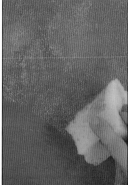

1 Apply the glaze without too much attention to brush marks.

2 Place the rough face of the sponge onto the surface to remove the glaze. Sponge the area roughly, using a similar technique to sponging on.

3 To fill in, lift the darker areas of glaze which were missed in the initial sponging.

4 Sponging off results in a softer, more overall effect than sponging on.

LEFT: *Immovable or intrusive objects such as radiators can be camouflaged into an interior by careful sponging.*

BELOW: *The area above the chair rail displays sponging on and off in soft tones of beige. Below the chair rail is a five-color random sponging that combines shades of red, pink, and white.*

SPONGING FURNITURE

Either the very soft finishes offered by latexes or the very sharp, vividly colored mottles created with oils work best on furniture. It is advisable to be definite. Light, leggy furniture should not be sponged except in oils, because soft effects just won't show up on it. Large furnishings – such as chests of drawers – work well with soft, marbled effects provided that they are protected with varnish, while tabletops and desks need a sharper, denser mottle, such as porphyry. The contrast achieved by sponging opening panels – such as drawers and cupboard fronts – while leaving the rest of the chest or cupboard unmottled, creates an interesting effect.

FLOGGING

*F*logging is a technique used in graining, and has only recently become an effect in its own right. More often seen on walls than on woodwork or furniture, this finish is usually most successful in subtle colors, but can look stunning in strong yellows, perhaps because of its resemblance to a cornfield. The effect is achieved in a subtracted manner, and flogging refers to the action of slapping the brush against the wet glaze.

The glaze is applied with a brush or roller and laid off in the same direction as the flog. Unlike dragging, the effect is initiated at the bottom of the wall, and the work progresses upward. A flogger or dragger is the only suitable brush, as long bristles are essential to the effect. As the brush slaps the glaze, it is also pushed across the surface, causing the outer bristles to splay slightly. The glaze does not have to be pulled over the surface, so providing the preparation is reasonable, the finish will be successful. Keep wiping the brush with a rag to maintain a uniform overall effect.

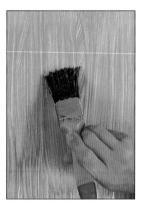

1 Apply the glaze, using either roller or brush, and lay off in the direction of the flog.

2 Start at the bottom of the area. Slap the glaze with the flogger, and at the same time move the brush in an upwards direction over the surface.

3 The completed effect has a more homey feel than that produced by dragging.

DRAGGING

Dragging is best suited to well-prepared flat surfaces, as it is a technique that will show flaws in the base. For the beginner it is best to attempt small items such as boxes, cupboards, and dado rails rather than to attempt walls immediately. The effect works well in conjunction with rag rolling and is an ideal background for stenciling and lining.

Your choice of color depends on the color scheme required. For a subtle, elegant look choose two subdued colors, such as dark cream over pale cream. For a bold look use contrasting colors that are strong and vibrant, such as apple green and bright blue, and yellow and orange.

Dragging is inexpensive but it does take practice, so a sample board is a good idea. Most mistakes are caused by applying too much pressure on the brush when dragging it through the glaze or by using too much glaze. Both problems can be overcome with practice. Any build-up of glaze on the panels of cabinets or doors can be removed by using a dry brush to lift the glaze.

DRAGGING WALLS

If you are attempting dragging on a large area such as a wall, where you have to use a ladder, try not to remove the brush from the wall as you work from top to bottom but work your way down the ladder keeping the brush at an even pressure. If you do have to remove the brush, carefully go over the overlap with a clean brush and try to vary the position of the overlap on each attempt.

1 Apply the glaze thinly and evenly, ensuring that it is laid off in the direction of the intended drag.

2 Drag the brush smoothly through the glaze, allowing the bristles to do the work. Hold the brush at an angle of about 30° to the surface.

DRAGGING WALLS (continued)

3 Wipe the dragging brush regularly with a rag to keep it unclogged and therefore able to produce the same effect across the surface.

4 The finished effect. The joins should be almost imperceptible.

DRAGGING WOOD

Woodwork must be dragged with the grain or, if chipboard is used, the way the grain would run. If there is a choice of direction, always drag the length of the panel. The most important aspect of dragging woodwork is the order in which the piece is tackled. If a standard panel door is to be dragged, each section should be dealt with individually. If need be, you can mask each section off and allow it to dry before working on the next. When you become more proficient, you will be able to complete the entire door without stopping. But it is essential to apply glaze and drag the confined pieces of wood first in order to achieve a clean joint line. The joints can be emphasized with a fine line when the glaze is dry to give extra sharpness. The finished texture is very subtle, giving an impression of opulence.

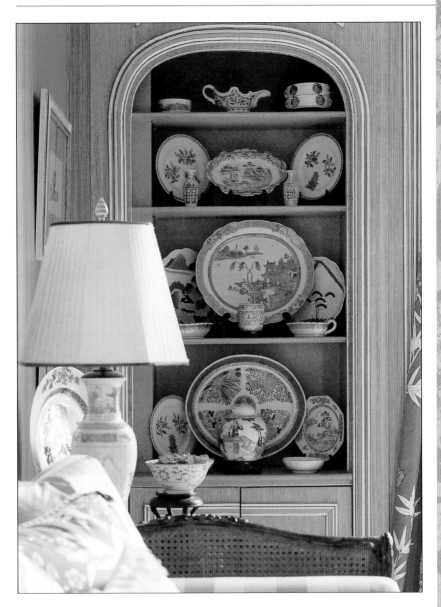

ABOVE: *The crispness of the blue dragged walls, together with the distressing of the surrounding moldings of the bookcases and window recesses, help to highlight the display of beautiful blue and white porcelain in this sitting room. This decorative scheme is brought together with the shades of blue-striped fabric covering the sofas.*

COMBING

There are endless possibilities for this simple finish, which is often seen in large scale on floors. Different combs and handling techniques can produce a multitude of effects ranging from the primitive to the luxurious. Combing was popular in the 1920s and 1930s, when it appeared in dull, somber colors. The combs were made of metal, cardboard, and wood, and were drawn over the surface of wet paint to produce a contrasting textured effect. The combs had been developed far earlier for the more refined process of graining, but by the beginning of the 20th century graining had gone out of fashion.

Combing can be tackled with water- or oil-based glaze. In fact, if the area is small enough, normal undercoat or emulsion can be used. Allow this to begin tacking off before you start combing otherwise the paint will flow back into the marks made by the comb. Rubber, leather, and steel combs are available through specialty shops.

BASKETWORK COMBING

This technique is primarily a floor application, but can be extremely effective on a smaller scale. Suited to subtle colors, such as soft greys and pale blues or yellows, the design can be applied in a chessboard pattern or at a 45° angle for more of a basketwork effect.

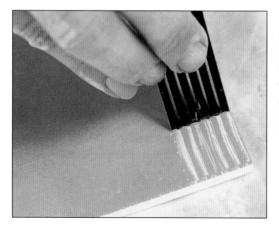

I First apply the glaze. Drag the comb (in this case a steel one) through the glaze, angling it slightly toward you. The drag should be roughly the same lengthy as the width of the comb.

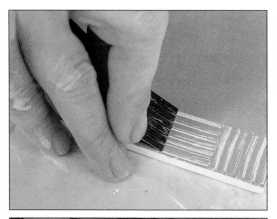

2 Comb at 90° to the first imprint, again angling the comb to produce a square imprint the same size as the first one.

3 Continue to produce the repeated alternating print, remembering to keep the comb clean by wiping with a rag from time to time.

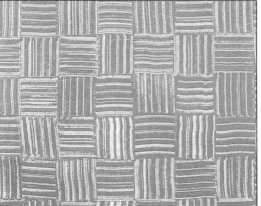

4 The finished effect. Some of the comb marks are bound to be a little skewed. This gives a softness and slight movement that adds to the effect.

WEAVE COMBING

You can create a weave or plaid effect by introducing a second or even a third color, strategically applied over a wet ground coat. Combs of different grades and widths, dragged across the surface at right angles to each other, help enhance this effect.

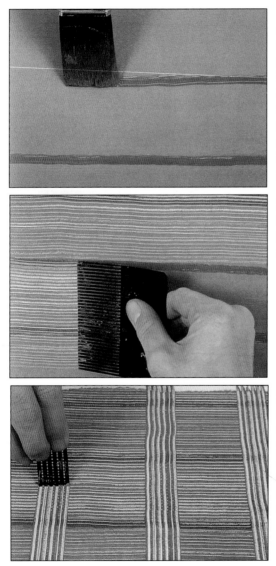

1 Apply the ground color and lay off (the aim of laying off is to eliminate any brush marks or at least to reduce them). Using a clean brush, paint on another color in stripes. The brush of the second color will need to be well loaded as the ground is still wet.

2 Pull a 4 in. (10cm) wide fine-grade comb across the surface, along the lines of the second color.

3 Using a 1 in. (25 mm) coarse-grade comb, drag equidistant stripes across your first marks, about 2 in. (5 cm) apart. The final effect has the appearance of a subtle, rich weave or a plaid.

WATERED SILK EFFECT

This effect is much more luxurious than most combing techniques and is produced here using a triangular rubber comb. Steel combs will create a finer and more delicate look.

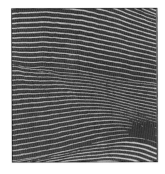

1 Apply the glaze and lay off in the direction in which the effect will run. Pull the comb through the glaze in a straight line, but smoothly change the angle of the comb, so as to produce an alternately broadening and narrowing stripe.

2 Create a second swirling stripe to fit snugly alongside the first. Each succeeding stripe should complement the one before: broad where the preceding one was narrow, and narrow where it was broad.

3 When the area is completed and while the glaze is still wet, pull the comb in a straight line through the pattern. As if by magic, a watered silk effect appears.

4 The finished effect, with its rings of watered silk, is particularly effective on small items or when combined with an antique finish.

COMBING FLOORS

Combing is better suited to floors than dragging, the soft, subtle texture of which is simply lost under foot and furniture. Combing can be executed on the bleached, primed wood of floorboards and on floors of chipboard and hardboard. The parallel pattern of floorboards, like the structure of a door, tends to dictate what finish is applied to them and most combing looks best following their direction and grain, whatever color combinations you may choose. These can range from mid-gray dragged over white, dark blue or mid-blue over pale gray, to scarlet over deep blue or magenta over golden ocher. It is certainly easier to comb on the floor. Gone is the fear of the vertical plunge to the baseboard that daunts the faint-hearted, and instead you can stop for coffee at the end of a floorboard without having to worry about the wet edge drying out. Hardboard and chipboard floors, with their smooth surfaces, offer extraordinary scope for patterning. Effects range from those formed by diagonally wood-blocked floors to the curves and swirls one sees in marble. Combing can also produce the kind of parallel patterns seen on Native American rugs or Spanish straw matting.

On floors, you must use flat oil paint, undercoat, or eggshell. Latex will come off after only very little wear and is therefore unsuitable. As always, you must prime new wood and then put on a full-strength undercoat and at least two slightly thinned ground coats – preferably three. The combing coat should be a 1:3 mixture of mineral spirits to paint – thicker than you'd use on a wall. This is absolutely necessary to give enough body to the finish. You can use actual floorpaint, of course, but its dense texture is less suitable for the combing coat and the color range is very limited.

Always make sure you work toward the door so that you are not trapped in a corner of the room. If you are making a pattern based on any geometric design, copy the design on paper first and divide it into regular squares; then, using chalk, divide the floor into scaled-up squares of equal number. Patterns with straight edges, where one direction of combing ends and another begins – like a chessboard made of contrastingly patterned wood – should be painted with masking tape along these edges and the floor grid should be painted in a checkerboard manner, with the alternate squares filled in once the others are dry. Floorboards are best done by coating and then combing about two at a time. Once the combing coat is dry, give it three coats of polyurethane varnish.

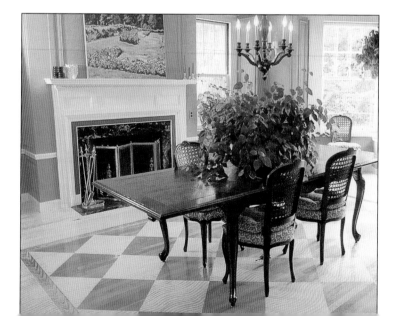

GRAINING

Graining is thought to date back to ancient Egypt where a shortage of wood stimulated the development of techniques to imitate wood grain. Similar faux, or imitation, wood finishes later emerged in Europe in response to demands for hard-to-obtain or exotic woods.

Today, techniques have become highly sophisticated and capable of producing effects that are indistinguishable from the original. Some of these are very complex, but you can achieve effective finishes more simply (and it is advisable to stick to these in the early stages). Once you have mastered the basic graining techniques, you may decide to move on to more complicated variations.

The three types of graining shown in this book are an introductory effect called clair bois (meaning pale wood), a mahogany effect suitable for large areas such as doors and furniture, and a bird's-eye maple for small pieces like boxes or mirrors. All the techniques have been simplified as much as possible to give an attractive effect with the least amount of effort.

As with most faux finishes, a feeling of depth is achieved by layering the different colors. In most cases the medium is transparent oil glaze, sometimes in combination with a wash. The ground color should be a shade lighter than the palest part of the wood being copied, and the graining color, or top coat, should be a shade darker than the deepest part.

CLAIR BOIS

This pale wood graining effect is easy to achieve and can be extremely effective, especially when used in conjunction with black borders or lines, which will give a late French Empire or Biedermeier look to a piece.

I Brush on the oil glaze mixture and lay off in the direction in which the grain will run. Use a flogger to pat the glaze in such a way that almost the entire length of the bristles is in contact with the surface. Work away from your body, lifting the flogger off the work before patting.

2 The finished effect closely simulates a pale wood.

BIRD'S-EYE MAPLE

Used in the past for large areas, such as paneling, a bird's-eye maple effect is extremely attractive for small pieces, such as boxes or mirror frames. The medium in this example is water based, which gives a cleaner and finer finish. It is applied over a pale honey oil-based ground, and in order to allow the water-based wash to spread freely, over the

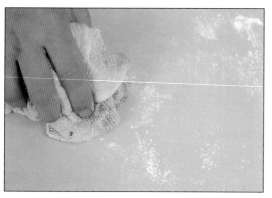

surface, all surface oil must be removed. When making the bird's-eye marks with your dampened fingertip, try to avoid making the prints too contrived or you may get a polka-dot effect.

I Rub over the oil-based ground coat with whiting, using a pounce bag or rag.

2 Apply the raw sienna/raw umber mix, and lay off in the direction of the grain.

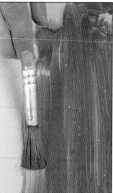

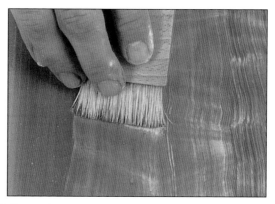

3 Drag a hog-hair mottler across the surface, moving one edge of the brush slightly in front of the other, and then the reverse, in an action like walking.

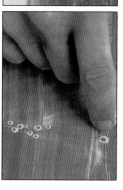

4 Dampen the tip of your finger and touch the wet wash to create the bird's-eye marks. These should be scattered over the area randomly but in vague groupings.

5 Soften the entire surface using a badger brush in all directions. This brush is so soft that it barely supports the weight of its stock. It should be used so delicately that the tips of the bristles barely touch the surface during the stroke, and it will gently blur the wash into a softer effect.

6 The pattern should not look repetitive. It helps to have a picture of the real wood as a visual reference while you work.

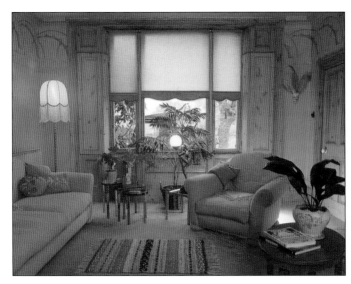

LEFT: *Wood graining used in conjunction with stenciling. The arching patterns of the stenciling balance the regular angularity of the wood, and the wood gives a visual anchor and stability to the stencil.*

MAHOGANY

This finely figured wood was first used by Europeans to repair their ships while exploring the West Indies. One of its earliest documented uses in England was Nottingham Castle in 1680, but over the next 50 years it became so popular that regular shipments from Central America could no longer meet demand, and a further supplier had to be found. Mahogany began to be imported from Africa as well, and fine veneers were glued onto a framework made from deal, so as to reduce the cost.

The graining of the this wood is more complicated than the two earlier examples. As with many graining techniques, there is more than one application. The undergrain is allowed to dry before first a figuring glaze and then the overgrain are applied on top. The undergrain is often oil based, and the overgrain water based to give a finer finish, but it is easier to practice the method with one medium at first, and in this example oil-based glazes are used throughout. The ground color for mahogany should be a brownish terracotta hue, but an exact match is not necessary. The color of a piece of wood depends on many factors, and it would be impossible to dictate a color that reflects all the individual variations found in nature.

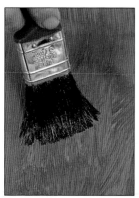

I Rub on the thin undergrain glaze with an application brush. Lay off in the direction of the grain.

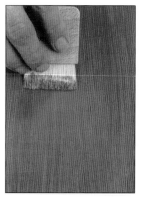

2 Using a mottler, drag with the proposed grain to produce even coloring and a faint drag.

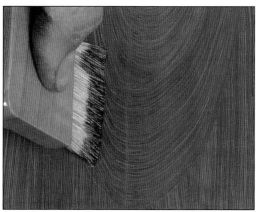

3 Continue with the mottler, this time used at a 90° angle to the previous strokes. Maintain this attitude as you etch in the annular rings, starting at the bottom with the smaller ring and building up. In this way, the bands get larger as they reach the summit of the figure and reduce as they fall level with the center.

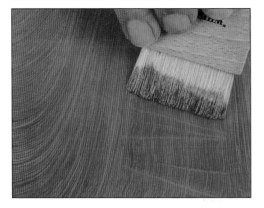

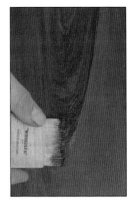

4 Once you have put in the main figure, gently drag in the remainder of the panel with the mottler returned to its original attitude. A slight movement of the hand similar to the technique used in bird's-eye maple will feather the edge. Leave to dry.

5 Using a hog-hair mottler and a figuring glaze, repeat the technique in step **3**. However, in this case the glaze is being applied instead of being removed.

6 Soften the figuring from the center outward with a badger-hair brush and allow to dry.

7 Apply the overgrain glaze, laying it off in the direction of the grain.

8 Flog the panel with a flogging brush working from the bottom upward, using a similar technique to that for *clair bois*. Once dry, the panel should be varnished.

9 The finished effect relies for its success on the pattern, depth of color and smooth surface.

OAK WOODGRAIN

Over the years many rare and precious woods have been simulated in faux paint effects and probably none more so than grained oak. The most beautiful of grained effects can create the look of expensive and sought-after antiques from simple everyday objects.

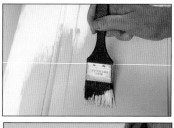

1 Apply an undercoat and allow to dry. With a 2–3 in. (5–7.5 cm) bristle base coat brush apply at least two coats of buff eggshell paint. Allow to dry thoroughly between coats and before commencing the next step.

2 In a clean dish, mix some transparent oil glaze. In another dish, mix together one part raw umber, two parts yellow ocher and three parts burnt umber with a little white spirit. Add the glaze and mix completely. Add a little white spirits to achieve a pouring consistency.

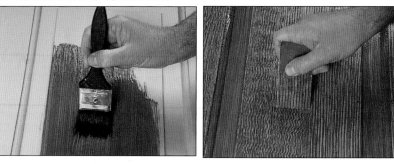

3 With a 2–3 in. (5–7.5 cm) bristle brush apply a fairly generous layer of glaze to the surface. Cover the surface completely and use the brush in one direction only. With a stippling brush stipple out all visible brushstrokes. Remove any excess glaze with a soft cloth.

4 Drag a wide-toothed metal graining comb cleanly and vertically through the wet glaze. Continue across the surface removing excess glaze from the comb with a soft, lint-free cloth as necessary. Repeat over the surface but this time ever so slightly wave the comb to create the very characteristic close oak grain.

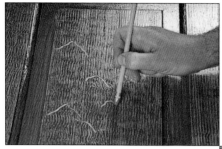

5 Using either an eraser, cloth wrapped around your finger, or an eraser-tipped pencil, pass the eraser through the glaze in upside-down "V" shapes in roughly diagonal lines across the surface. Be careful not to overdo this as the look can easily be destroyed.

6 The texture and density of natural oak have been achieved here using a simple combing technique. Both the color and the thickness of the glaze create the substance and strength of sawn oak. This texture would be enhanced by liming (see page 72), which would mellow the final effect to a soft, chalky finish.

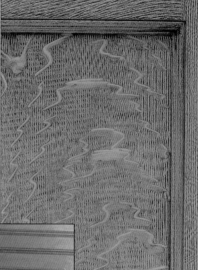

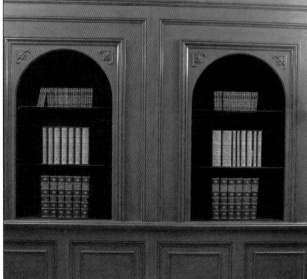

LEFT: *A mixture of burr walnut and fantasy woodgraining provides a fitting setting for the leatherbound books in this study. Oil glazes were applied over a water-based ground and then finished with varnishes – five coats in total.*

STIPPLING

Originally stippling was a way of distributing paint or glaze as evenly as possible. Many original paint effects involved stippling the ground or glaze color prior to finishing. Authentic standard stipple is only achievable with transparent oil glaze, because the effect is so fine that the medium must possess enough hold to preserve its texture without flowing back. The subtlety and finish of this effect are also enhanced by the glowing transparency of an oil glaze. the glaze is applied with a brush or roller and laid off in the usual way for subtracted finishes. A brush is then bounced across the surface with a pouncing movement, producing a fine pepper-like orange-peel finish.

Stippling is not an effect to undertake lightly. The physical effort required is greater than with any other finish. You will have to bounce the brush over the entire surface, so the bigger the brush the better when decorating a room. For such sizeable areas, it may be advisable to purchase a large stippling brush. These are extremely expensive, however, and it's worth experimenting with some alternatives beforehand. A decorator's dusting brush, a broom head, a soft-bristle hairbrush, a shoe brush – all have been used with success.

STANDARD FINE STIPPLE

A standard stipple requires top-quality preparation: the effect is so finely textured that any flaw stands out like a sore thumb. After applying the glaze, bounce the brush across the surface, letting the bristles act like springs. Hold the brush at right angles to the surface to prevent skidding. Angle the attitude of the brush to ensure that any lines caused by the brush shape are not as obvious as they would be if they were horizontal or vertical. Rub the brush clean regularly with a rag to maintain a uniform effect.

When working on a large surface, and following the recommendations for subtractive finishes, it is advisable to step away from the area to check the overall look, and to jab the brush lightly at any dark patches. This effect needs extreme caution because of its fine texture. Any accidental damage will be very evident. If damage occurs and the surface is still wet, reapply glaze quickly to the affected area and restipple. If, however, the glaze has begun to dry, or tack off, a renewed application of glaze will react against the tacky glaze and worsen the fault. If you can live with the fault, leave it. If not, remove the glaze with rags and white spirit, and allow the surface to dry for at least two hours before reapplication.

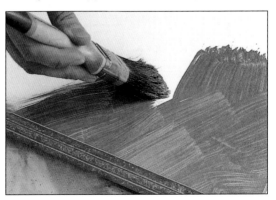

I When finishing an edged surface, such as this tabletop, apply the glaze first to the edge and then to the larger top.

2 Lay off the glaze lightly with an unloaded brush.

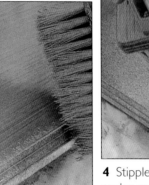

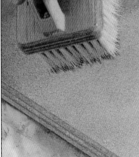

5 Use a piece of cheesecloth wrapped around your finger to achieve a wiped, dragged look over the molding.

4 Stipple the top, holding the brush at right angles and allowing the bristles to act like springs. Remember to wipe the brush occasionally with a rag to remove the glaze.

3 Stipple the edge first, because this cannot be done without overlapping the top.

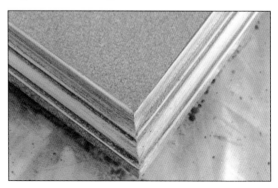

6 The finished piece demonstrates the subtlety of this technique.

COARSE STIPPLING

This effect was achieved in a similar way to the standard fine stipple, but substituting a plastic Artex stippler for the bristled stippling brush. This much coarser stipple can be useful when there is a danger of the standard fine stipple being too subtle and you want a nondirectional effect that looks more stone-like and will have greater impact. However, using a plastic Artex stippler is much more tiring than using a stippling brush, so think carefully before you decide to apply this finish to a large area.

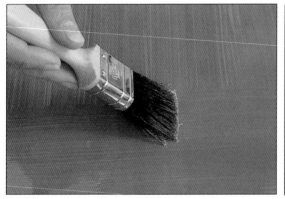

1 Apply the glaze and lay off with an unloaded brush.

2 Bounce the stippler over the surface. Very little spring is offered by the stippler, so it helps to relax the wrist a little to gain a certain rhythm. Stipple the complete glazed area, occasionally cleaning the stippler with a rag.

3 Return to the surface using a lighter touch. Alter the brush angle while maintaining a parallel stippler-to-surface attitude to remove patches and lines.

4 Coarse stippling is particularly useful for giving a stone-like finish on dados, skirtings, and architraves.

MULTICOLORED STIPPLING

This stippling technique dates back to the 1930s, when it was popular in cinemas and cocktail bars. As the name implies, a number of colors are used, and give a smoky, cloud-like effect, which also makes a good ground for marbling. Up to three or four colors may be used together, and these should all be roughly the same strength. Patches or bands of the chosen colors are applied to the ground coat while it is still wet. The colors are then blended together by stippling. It is important to apply the ground coat thinly and evenly, and because of the amount of wet glaze on the surface, the stippling brush will need wiping frequently.

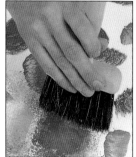

1 Apply a white or colored ground mixed from one part glaze to two parts paint and thinned up to 10 percent with white spirit.

2 Add the colors separately, using a different brush for each color. Load the brush a little more than normal to aid application onto the wet ground.

5 This smoky, floating effect seems to drift over the surface, shifting from one color to the next.

3 A dusting brush is a good choice for this effect. Use it to stipple outward from one color to another, remembering to clean it regularly with a rag. Do not pick up the stippler when it is loaded with one color and begin stippling on another. this will muddy the effect.

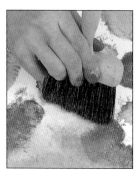

4 Once the colors have made an initial mix, go over the area again using a lighter touch and a newly wiped brush to complete the overall blend.

BLENDED OR TONAL STIPPLING

Unlike standard stippling, this effect was originally achieved without the addition of oil glaze. However, its use has expanded the boundaries of this mood-changing finish, which is nearly always used on walls to lend atmosphere.

The base coat for blended or tonal stippling is a mixture of two parts boiled linseed oil and one part white spirit mixed with three parts of the suitably colored undercoat. Apply this by brush or roller and allow to dry. The dried surface will be extra-shiny and slippery and will allow the top coat more movement than normal. Divide the wall into three horizontal bands, marking them every so often with a dash of chalk. Mix three glazes for the top coat. These could be tints of the same color but of different strengths, or two colors that mix to form an attractive third color. Using transparent oil glaze in conjunction with pure color adds a luminous quality to the effect. However, the original method involved the use of normal, slightly thinned oil-based paint, and relied on the oil quality of the base coat to achieve the effect.

Apply the bands of color in the marked areas, in patches of about 3 ft (1 m), stippling each patch before coating another section of wall with the three glazes. Pounce the stippling brush through the glaze, starting in the lightest glaze and traveling through to the darkest. At this point it is essential to rub the stippler clean with a rag. If you return the brush to the pale glaze without this cleaning, the effect will be ruined.

When finishing a sizeable area, it is advisable to utilize two stippling brushes, one for the upper half of the wall and one for the lower half. These should still be kept clean with a rag, although there will be less of a problem with color contrast on the brushes.

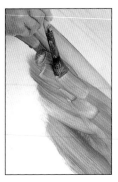

1 The oil-containing ground mix has dried, and the first pale band of glaze has been applied to the top part of the wall. Here the second, mid-tone glaze is being applied.

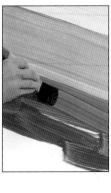

2 The third and darkest glaze is applied and laid off horizontally.

4 The completed finish, showing the soft graded effect.

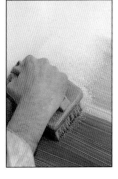

3 The stipple brush is pounced over the surface, traveling from the pale band through the mid-tone to finish at the bottom of the wall, where it is rubbed clean with a rag before returning to the pale area.

STIPPLING WITH A BRUSH

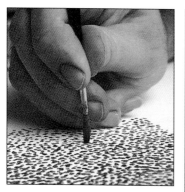

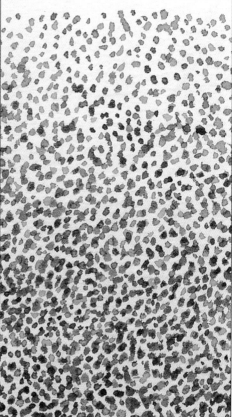

1 Shading and texture can be achieved by building up a mosaic of fine dots using a small, well-pointed brush. Hold the brush almost at a right angle to the painting surface and repeatedly touch the tip to the surface without pressing too hard. Try to space the dots evenly and make them about the same size. Paint for stippling should be quite fluid, but not too runny; shake the brush to remove any excess moisture and avoid drips and runs.

2 Stippling produces an area of color that appears lighter and brighter than the equivalent color applied in a flat wash. The overall effect can be extremely soft and subtle, especially when used over a wash of color. If you wish to increase the density of value in an area, apply more dots but do not increase their size. Experiment by intermixing two or more colors; graduating from one color to another; and applying a stipple over different-colored washes.

The softer hairs of a decorator's brush produce a slightly blurred, more irregular stipple. A worn, ragged paintbrush with splayed hairs is also useful for stippling.

STIPPLING WITH A SPONGE

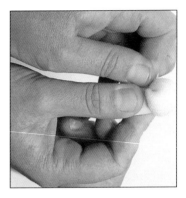

1 You can also stipple with a small, round sponge – synthetic ones will produce a more regular pattern. For small areas, make a stippling tool by wrapping a piece of sponge or foam rubber round the end of a paintbrush. This will give you greater control over the technique.

2 Make sure the wad of sponge is thick enough to prevent the sharp point of the brush handle from sticking through, and tape it firmly in position.

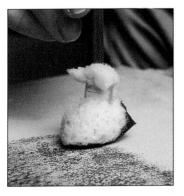

3 Moisten the sponge and dip it into fairly stiff paint, then apply with a press-and-lift motion – don't scrub.

4 Keep dabbing and lifting, over-lapping the patterns until you achieve the density and texture that you want. Try dabbing one color into another, or producing values from light to dark by altering the density of stipple.

RAGGING

Ragging covers a selection of finishes that rely on the contours of fabric. The fabrics used range from linen to plastic, and their effects are dramatic and diverse. Colors for this effect are normally soft, and the base color is nearly always the paler one. The obvious exception is frosting, which is achieved with a white or off-white top coat. The majority of the effects are subtracted and therefore require a certain amount of planning when large areas are to be finished.

The procedures needed for ragging, and their results, vary in two respects. First there is an enormous choice of materials, from paper to chamois leather, each of which will give a different texture. Second is the way in which the chosen material is manipulated – whether rolled across the surface or pounced in a similar way to stippling. The application of the top coat can be by brush or roller. If you use a brush be careful to lay off the glaze and therefore lessen the brush marks. The effect is one of the most dramatic and can be used for a wide variety of purposes. The crushed velvet texture can take on a marble-like appearance,

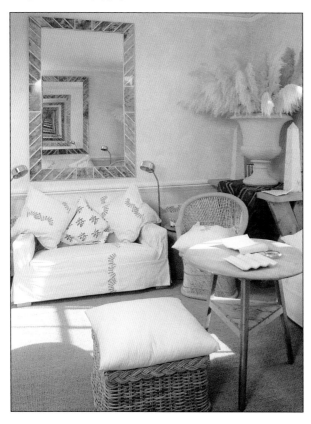

especially when a gray or stone color is used as the base and paler mid-tone as a top coat. Many a coffee table has been improved with this technique.

LEFT: Ragging gives a damask-like or white velvet texture to these walls where a plain surface would be excessively neutral. But the walls must be "quiet," as the warm honey-ocher tones of other surfaces are gentle and discreet in themselves, while having a very distinct tactile quality.

RAG ROLLING

This effect is produced by rolling a lint-free rag over the wet surface of the glaze. Any material can be used, providing it is lint-free and clean, and unlikely to bleed color. Toweling will create a soft texture, while a nonabsorbent plastic bag will leave a sharp, well-defined look. Most important when choosing your material is its quantity. If you are finishing a large room, you will need a plentiful stock of material, so that sodden rags can be replaced.

The preparation should be of good quality, but rag rolling is kind to its surface. This makes it especially appropriate for a wall that is sound but has undulated as old walls often do. Unlike dragging, which would highlight the lumps and bumps, rag rolling will make these less apparent.

Many techniques have been offered over the years to achieve this effect, but the original procedure has yet to be bettered. The technique is to crush the fabric several times by twisting it up and then unraveling it. This will give it some initial character. The material is then gathered into a loose bunch and rolled in a diagonal course over the surface with the lightest of pressure. Avoid using the rag tightly rolled as this produces a repeated pattern and heightens the danger of skidding. Try to fill the area without rolling vertically or horizontally, as the eye will pick this up and the finish will be marred. Once you have covered an area, stand back and blur your eyes to check for dark patches. These can be blotted to keep the undulating effect even.

When you have completed the work or are taking a break, be sure to spread or hang out the used rags that have glaze mix on them, so that they dry thoroughly.

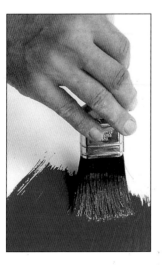

I Apply the glaze – in strips of about 2 in. (60 cm) wide for a large area.

2 Lay off the glaze lightly, spreading it out and eliminating brush marks.

4 Blot darker areas and check the evenness of the finish by standing away from it and blurring your eyes. Lighter areas or bald patches may be remedied by ragging on a little glaze with a wet rag.

3 Roll the loosely bunched rag across the surface in a diagonal direction, applying only delicate pressure. Fill in, using angled runs, avoiding the vertical and the horizontal.

5 The completed rag-roll effect should tumble and twist across the surface. Viewed from a distance, the movement should be soft and not patchy.

BAGGING

Bagging, or bag stippling is one of the simplest subtracted effects. The choice of medium is limited to a transparent oil glaze, because a solvent is sometimes required to break up the glazed surface. A brown paper bag dipped into white spirit or turpentine substitute and scrunched up gives a crackled effect. Plastic bags are also used, and the thicker and more robust the bag the crisper the effect. A relatively soft supermarket bag, which produced a subdued texture, was used in this example. Bagging is a soft, luxurious effect which, in some colors, can look like marble. It is best suited to smaller areas, woodwork, or on the walls of an opulent dining room.

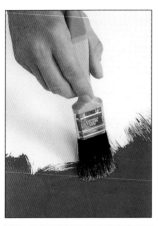

I Apply the glaze with a brush or roller.

2 Spread out the medium, and lay off to reduce brush marks.

3 Pounce the bag over the surface. It is unlikely that more than one bag will be needed, because very little glaze is picked up by the plastic – it is merely redistributed.

4 The finished effect is luxurious, relying almost entirely on texture rather than the contrast between the ground and top coat.

RAGGING ON AND FROSTING

Unlike other rag effects, these are applied finishes. The glaze is applied to the dry ground or base coat with a rag. the choice of rag is wide, but it must be reasonably porous in order to carry the glaze.

RAGGING ON *Ragging on probably evolved from rag rolling, where it is often used to correct an error. Suitable colors are closely linked to those for sponging on, as is the technique. The effect can be achieved with any glaze, but water-based glazes are most often chosen because of their quick drying. The only tools you need are those for preparation, together with a rag, some glaze, and a card for testing. Dip the rag into the glaze and test its print on the card. Once you have an acceptable print, you are ready to approach your surface. The effect needs to be built up gradually, and because this is an applied effect, you can stop at any time and resume at a later date. The technique is the same as for sponging on, with the rag taking the place of the sponge. As an applied finish, ragging on has obvious advantages. In addition, it provides a sharp, more aggressive contrast between the ground and the top coats. The finish is often used on walls, but with very soft colors to make the overall effect easier on the eye.*

FROSTING *Frosting is a finish that works to great effect over many different grounds. It is achieved by either sponging on or ragging on, and is frequently used to refinish a decorative scheme quickly and inexpensively. It is often applied over paint effects that need lifting because they have become too heavy. A white or off-white top coat, put on by rag or sponge, is gradually worked up, as described in sponging on, until it almost conceals the original surface. Although technically a color reversal of two other effects, frosting is widely regarded by decorators as a finish in its own right.*

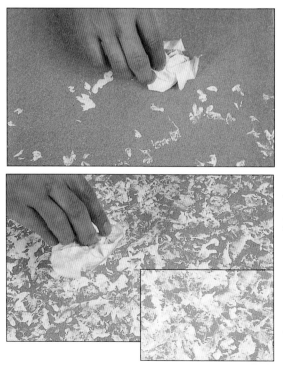

1 The white glaze is applied with crumpled paper.

2 You should cover the whole area and gradually build it up, taking time to step back regularly and check the patches.

3 The completed effect is crisp, reminiscent of a frosty morning.

GOLD AND SILVER FOSSIL

These effects, named for their appearance, are very much part of the rag finishes. The technique is the same as that for ragging and rag rolling, but the glazes are different. The effect is luxurious, and should, therefore, be used sparingly. It is normally confined to furniture and accessories. Emulsion glaze is used for both finishes, mixed with bronze powder for the gold effect or aluminium powder for the silver, and thinned slightly. The base coat should be a dead flat black and good preparation is important. The surface must be very smooth.

GOLD Lay the gold glaze onto the ground coat with a brush. Roll a piece of cheesecloth across the surface but press firmly. The fine powder will adhere to the ground, and the medium will be absorbed by the rag. Take care as you roll to push or pull the gold mixture into a pleasing effect. The holes in the cheesecloth will contribute to this, and the bits of lint left on the surface can be removed when dry. A spattered effect can be added to the damp glaze with the aid of methylated spirit (see silver glaze).

SILVER Aluminium powder is mixed into the emulsion glaze in the same way as the bronze powder, but needs a slightly thinner mix, produced by adding more water. The application – again only by brush – should be quickly followed by the ragging technique. Use a cotton cloth, twisting it slightly while it is pounced to produce a good print. At this point, you can create a further effect by spattering methylated spirit over the area. This releases the glaze in spots and pools, an effect that can also be achieved with the bronze glaze.

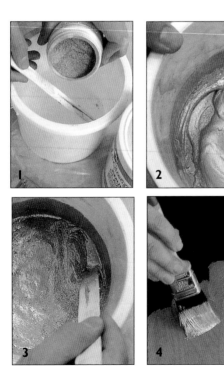

GOLD

1 Pour the emulsion glaze into a paint kettle and add a little bronze powder.

2 Mix the powder and glaze with a little water and continue adding bronze powder a small amount at a time.

3 Do not allow the mixture to become thicker than heavy cream.

4 Apply the glaze with a brush. Do not spread too thinly.

5 Rag roll the area with mutton cloth, exerting a firm pressure to move the glaze.

6 When the surface is dry, the lint from the mutton cloth can be rubbed off, leaving an undulating, luxurious finish, which should be protected with a glass or satin varnish.

SILVER

1 Use a brush to apply the glaze, which should be slightly thinner than its gold counterpart.

2 Rag the glaze in a pouncing movement, using a lightly twisted piece of cotton. Apply some pressure to the rag and slightly skid or twist it if it becomes difficult to acquire a good print.

3 Use an old toothbrush to spatter the still-wet surface with methylated spirit.

4 The finished effect is almost molten in texture, ideal for an art deco style interior.

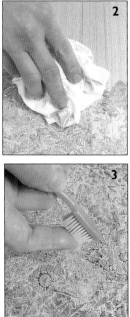

LIMING

Liming creates a soft, mellow finish that allows the natural look of the woodgrain to show through. The effect is reminiscent of seaside boardwalks and sun-bleached woods. Liming dates back to 16th-century Europe, when an unction containing the very corrosive slaked lime was applied to furniture and paneling to prevent worm and beetle infestation. Trapped in the pores of the open-grained timber, such as oak and elm, that was most widely used at the time the white paste not only repelled the pests but also produced a pleasing visual effect. This became increasingly popular reaching its height in the 17th century.

Open-grained wood is still the best for this effect, and you will only need to give it a light brushing with a wire brush prior to treatment. Close-grained woods will need more brushing. Once the grain has been readied in this way, you can apply a liming paste. Specialist shops supply liming wax, but this cannot be sealed. Instead you could use a white emulsion thickened with a little plaster of paris, as in the example here. Work the paste into the wood with a brush and then rub it off with a rag, leaving the wood to dry pale and ghostlike. Apply a sand sealer, and when this is dry, gently sand the surface with a fine paper. Protect the effect with an extra pale varnish. A splatter of black is sometimes added to suggest age.

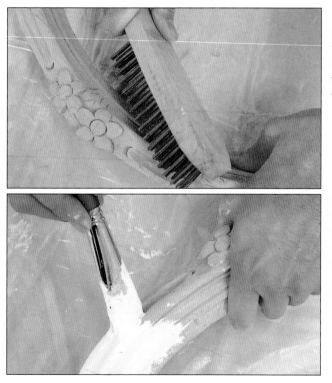

1 Open the pores of the wood by brushing along the grain with a wire brush.

2 Apply a coat of liming paste mixed from white emulsion and plaster of paris, working it well into the raw wood.

3 Use a clean dry rag to remove the excess paste.

4 Apply the sand sealer with a suitable brush and allow to dry.

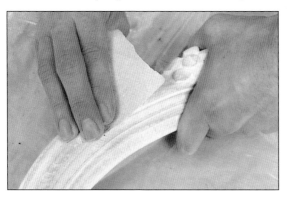

5 Sand the piece with a very fine paper to create an ultra-smooth finish for varnishing.

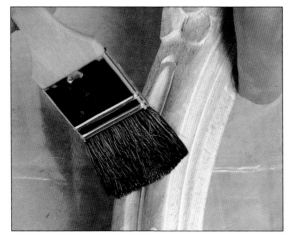

6 Varnishing brings the finish alive, revealing how the grain has picked up the white flecks of liming paste.

7 This technique is ideal for chairs, tables, and picture frames.

LIMING VARIATIONS

VARIATION 1 *In this painted variation a white glaze has been painted over a dark brown basecoat. The glaze was then "flogged" with a long-haired dragging brush, working from the bottom up and "flicking" the bristles.*

VARIATION 2 *Here a white glaze has been painted over a basecoat of vivid purple, allowed to go slightly tacky, and then fine-grade steel wool passed across the surface, following the grain at all times. This creates a very passable version of simulated liming.*

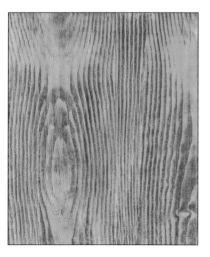

VARIATION 3 *An acrylic glaze made from 1 part mid-green emulsion to 3 parts acrylic glazing medium was applied over a mid-gray basecoat. The woodgrain effect was achieved by passing a heart graining tool (or rocker) through the glaze. When dry, diluted white emulsion (1 part paint to 6 parts water) was brushed across the surface. Finally, a protective coat of matte acrylic varnish was applied.*

DRY BRUSHING

Dry brushing can enhance furniture, walls, ceilings and floors as well as decorative objects such as picture frames, candlesticks, and boxes. Creating tactile textures and incorporating them in both traditional and modern settings is extremely easy with this technique, requiring only a little practice.

Dry brushing involves the use of brushes with very little paint, and the most common mistake is overuse of paint. You can solve this problem by practice and by using less paint on the brushes than you think necessary. Go over the surface a few times rather than applying too much paint initially and having to remove it. If you have applied excess paint and cannot remove it, allow it to dry and use the dry-brush technique again, but use the basecoat as the topcoat.

DRY BRUSHING A LOUVERED DOOR

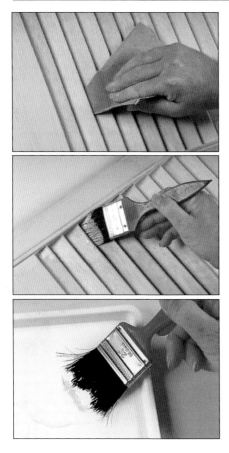

1 Prepare your surface. Sand the surface until smooth with very fine sandpaper. Fold the sandpaper in half to reach the areas between the slats of the louvered doors. With a fine, soft brush, remove excess dust from the surface area.

2 With a 2–3 in. (5–8 cm) basecoat brush apply mid-blue eggshell paint. Dry for 24 hours. Repeat if necessary, including all the areas beneath, on top of, and in the corners of the slats. When dry, check that no areas have been missed.

3 Put a little pure white artists' acrylic paint on a clean dish. Using the bristle brush, dip it into the paint making sure that you only pick up a small amount of paint. Dab the brush onto some clean paper towel to remove excess paint leaving the brush as "dry" as possible but still with a workable amount of paint.

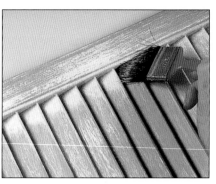

4 Quickly brush the surface of the door, working up and down the sides with quick strokes. Only just touch the surface with the bristles. Keep doing this along the sides until you have the effect you want. Then do the same backward and forward across the slats. Slightly enhance the corners with a further overlay of dry paint. Leave to dry.

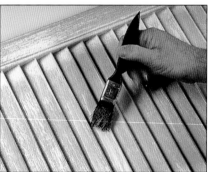

5 Apply two coats of varnish using a varnishing brush. Here we have used a flat acrylic varnish to keep the dusty, soft look, but a satin or gloss varnish may be used if preferred.

6 This ordinary louver door has been given a sun-washed look by the simple technique of dry brushing. The mid-blue overpainted with white has created a "fresh" feel. Finishing with a matte varnish has left a soft, chalky look like the sunlight effect on seaside boardwalks.

FROTTAGE

rottage creates a bold textural effect that is suited to almost any surface and item, from walls, ceilings, windows, and doors, to smaller, decorative items such as tables, boxes, lampbases, and picture frames. Choosing color combinations is great fun and experimenting with different color ranges will result in attractive and unusual results. Since few tools are required, your initial outlay is minimal. The most common mistake is allowing the topcoat to dry too quickly. This means that the newspaper cannot create its characteristic pattern. To avoid this, work on small areas at a time. However, if the topcoat does dry too quickly, remove it with a soft, wet cloth, add a little more glazing medium, and reapply. For large areas it is safer if two people work together, one applying the topcoat and the other creating the pattern.

If you are working on a large area you will need a good supply of fresh newspaper and drop cloths to protect your furnishings from the discarded newsprint. Preparation is easier, as the finish, in its own right, tends to cover most minor surface defects such as cracks or flaws. But for a good, professional finish, thorough preparation will always result in a top quality end product.

FLAT PAPER FROTTAGE

1 Lay a patch of color, using rich paint thinned with a little oil and turpentine. The thicker the paint you use, the heavier and more ridged the texture will be.

2 Place a sheet of nonabsorbent paper over the paint and press it down gently. Rub lightly over the paper with your fingertips.

77

3 Peel the paper away. Because the paint is tacky, the paper drags at it, forming a rough, stippled surface. To alter the texture, you can replace the paper and move it about or rub it. Experiment until you get the effect you want. Leave the painting to dry for at least 48 hours.

Below is the finished effect.

CRUMPLED PAPER FROTTAGE

I Apply a patch of thick paint as before. Crumple a sheet of non-absorbent paper into a ball, open it out, then press it into the wet paint.

2 Carefully peel the paper back from the paint. This creates a more pronounced texture than that achieved with flat paper.

CLOUDING

Clouding is a more difficult finish to achieve successfully, but the beautiful, ethereal effect of clouding will add a little bit of magic to any room. When created well, it can give depth and dimension to the most average of settings. Clouding works well on any smooth surface, such as walls and ceilings, and some furniture and cupboards.

STEP-BY-STEP CLOUDING

I Prepare the surface. If the surface you are painting has an area that you do not want to touch, as with the dado rail on this wall, use masking tape to protect the area. Place the edge of the tape as flush as possible against the rail.

2 Apply an undercoat using the bristle brush. Press up tightly along the full length of the dado rail and follow by either using a roller or a 3–4 in. (7.5–10 cm) basement brush. Allow to dry. Apply at least two layers of base coat, allowing drying time between each coat. We have used white semigloss latex.

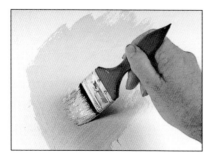

3 Mix mid-blue latex with acrylic glazing medium, I part paint to 6 parts glaze. Stir well and dilute with water until it is like light cream. Mix enough to cover the surface. Use a color washing brush to apply glaze to the base coat and keep a wet edge. Vary direction to help blending. Use a clean brush to spread evenly.

4 With a soft, lint-free cloth or a synthetic (cellulose) sponge remove random areas of the glaze to create patchy white and blue shapes. Work as quickly as possible, as the working time of the glaze is about 15 to 20 minutes. Make sure you keep a wet edge.

5 When the surface is blended to your liking, soften out the brush strokes using a badger softening brush (or a dusting brush). Work quickly, otherwise the effect will dry with darker, patchy edges.

6 Apply a coat of matte acrylic non-yellowing varnish with a varnishing brush.

7 Here our walls have been given an ethereal finish by choosing natural colors that evoke hazy, azure skies. Blues, often thought of as cold colors, can be warm and relaxing. Clouding is an effect that is easy to live with and adaptable for any room or decorative scheme, opening up rather than closing in space.

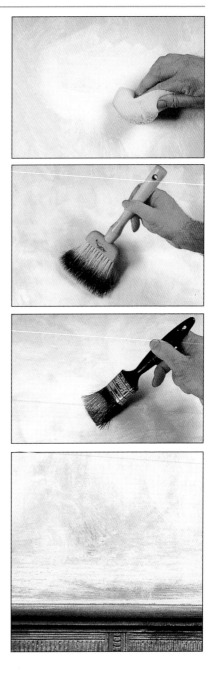

WAXING

Over the years wood develops a warm, mellow glow that comes after being treated with a great deal of loving care. This beautiful patina can be easily created through waxing, a rewarding and inexpensive technique that can be applied to many different items and areas of the home. Waxing is a very simple technique to carry out, and can result in satisfying effects requiring little or no practice.

Furniture, cupboards, dado rails, floors, picture frames, decorative sconces, pilasters, and even walls and ceilings, can be waxed. The surface to be waxed must be absorbent whether it is natural or painted, and waxing should not be applied to vulnerable areas subject to great wear and tear.

STEP-BY-STEP WAXING

I Use masking tape to seal off the area surrounding the surface to be waxed.

2 Prepare the surface by sanding. Remove all dust with a damp cloth. If the final effect required is one of heavy distressing, leave most of the imperfections to help accentuate the final look.

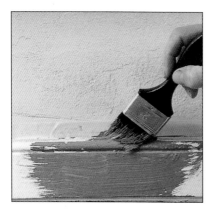

3 Apply a base coat of blue/green simulated buttermilk paint using a bristle brush. Make sure that any edges and recessed areas are not missed. Allow to dry for at least 24 hours.

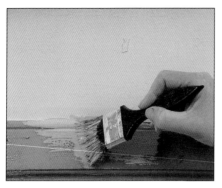

5 Apply antique brown furniture wax to the surface using fine-grade steel wool. Work backward and forward along the grain. Use enough pressure to gradually remove sections of the top and base-coat layers of paint. Coarser steel wool may be used for a more distressed look or to reveal underlying wood.

4 With a clean bristle brush apply a topcoat of yellow ocher simulated buttermilk paint. Allow to dry.

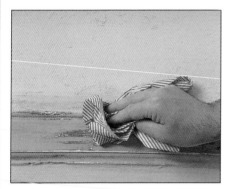

6 Once the final effect is achieved, allow the wax to dry. Apply another layer of wax. Allow to dry. With a soft, lint-free cloth buff the surface to a soft, mellow sheen. If a deeper color is required, add further layers of antique brown wax.

7 The simple technique of using wax and paint has transformed an old and well-worn dado rail, thus avoiding the expense of replacing it.

DISTRESSING

D istressing is one of the most effective paint finishes. It can create that valuable antique look from the simplest of everyday items or, when used in larger areas, that mellow, relaxing atmosphere of the "country look." You can distress subtly or noticeably. The choice is up to you. Distressing works well in settings of period charm or country simplicity, and it is very inexpensive to complete.

Ideally suited to wooden units, window frames, doors, dado rails, and baseboards, distressing also looks good on smaller pieces such as boxes, tables, and chairs.

STEP-BY-STEP DISTRESSING

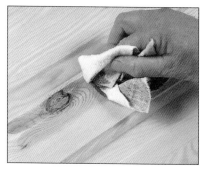

I Thoroughly sand the surface and seal any knots with shellac (knotting) solution applied with a clean paper towel or a soft, lint-free cloth. This helps avoid discoloration later caused by resin seepage.

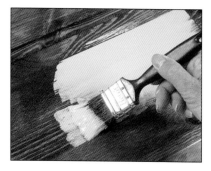

2 Using the ½–1 in. (1.2–2.5 cm) bristle brush, stain the surface with a coat of mahogany wood stain. Brush in the direction of the natural grain of the wood. By using a brush instead of a soft cloth, you will be able to get to the corners more easily. Allow to dry.

3 Using the 2 in. (5 cm) bristle brush apply a coat of ocher colored, water-based paint. Here we have used simulated buttermilk paint. Work along the grain of the wood and make sure that the surface is evenly covered. Allow the paint to dry and then lightly sand it. Remove excess dust.

4 Using simulated buttermilk paint in a dark green color, applying a top coat using a 2–3 in. (5–7.5 cm) bristle base-coat brush. Do not cover the surface completely but make sure that less vulnerable areas are covered. Dry for 24 hours.

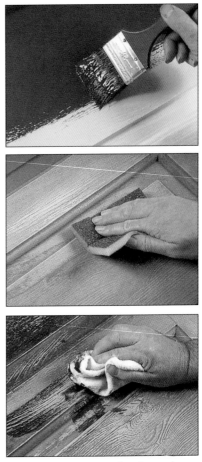

5 Sand the top coat in the direction of the grain in the areas that would naturally wear away over time to expose the ocher underneath. Continue to sand vulnerable areas, such as the edges and behind the doorknob, until you achieve the look you want.

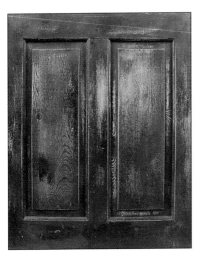

6 Apply two coats of antique pine furniture wax with a soft, lint-free cloth, following the manufacturer's instructions. (Use a soft bristle brush for any awkward areas.) Allow to dry and buff with a soft cloth for a soft sheen. This wax is used only for internal finishes.

7 This door has been distressed to show the natural wood, the knots, and the grain that has given the panels an aged beauty usually only possible after years of exposure to the elements.

ANTIQUING

Antiquing is a simulated ageing that can soothe a piece into its surroundings, as well as creating an atmosphere of times gone by. The term applies to a myriad of techniques and effects, ranging from the pronounced distressing, or time-worn look, produced by a wire brush to the fine speckle of a spatter. Most effects achieved with a color can also serve in antiquing. They cover applications as diverse as staining black-and-white prints with tea to ageing a new brass handle with boot polish.

The key to successful antiquing is subtlety. Where other effects ask to be noticed – even if elegance is their second name – antiquing needs the delicate tones and refined textures that will make a piece look as if it has been in situ for years. The colors normally used in antiquing are, therefore, rich, soft earth tones: raw umber, burnt umber, raw sienna, burnt sienna, and ivory black.

ANTIQUING OVER GOLD

Gilding is often antiqued, especially when applied to a classical design, where it may otherwise look too new and bright. First protect the gold with a thin tinted varnish that will seal the piece and give some definition to carrying. When the varnish is dry, use fine or medium grade wire wool to distress the piece. Concentrate on proud surfaces, edges, and areas more prone to wear and tear. The gold will be removed in places, leaving the ground to show through. Once you have achieved a pleasing look, choose a color for the antiquing glaze.

Gilding is usually antiqued with burnt umber or burnt sienna, because they impart a rich glow that is bold enough to reduce the gold's power but retain a warmth that enhances the piece. Oil glaze is the preferable medium, as metal leaf can sometimes react with water to cause tarnishing.

Mix your chosen shade with the glaze to form a strong color. Apply the glaze liberally over the area and allow it a little time to adhere. Then stipple or drag the glaze with an open-weave cloth, such as cheesecloth. This technique removes some of the glaze and ensures that all crevices and hollows have been thoroughly covered. Use a clean cotton rag, dampened with a little white spirit if necessary, to clean off the remaining glaze. Apply a varnish if you would like a sheen, but protection is not necessary, as natural wear and tear will merely add to the effect.

STEP-BY-STEP ANTIQUING OVER GOLD

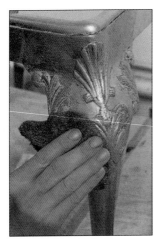

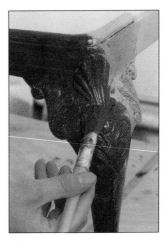

I Having protected the gilded surface with a thin coat of pale oak varnish and allowed it to dry, rub over the surface with fine or medium grade steel wool to give an impression of wear.

2 Mix the antiquing glaze – burnt sienna was the choice here – and apply it with a brush, taking care to penetrate all the details of the work.

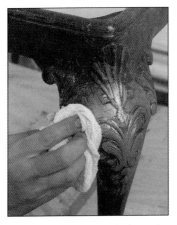

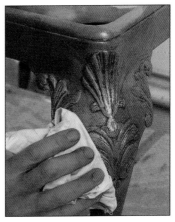

3 Using an open-weave cloth, such as cheesecloth, stipple, and rub the glaze over the entire surface.

4 Gently clean over the area with a clean soft cloth. In some instances, it may be necessary to use a little white spirit to produce highlights.

5 The antiqued effect warms and softens the gilding; the finished object glows rather than standing out brashly.

6 When a heavier antique finish is needed, drag the glaze over the moldings and carvings using cheesecloth; only the high points will appear as clean gold. The remainder will vary in tone according to their position.

ANTIQUING WOODWORK

GLAZING Paint glazes or oil glazes are among the most versatile antiquing approaches on woodwork, oil glazes offering the greater translucency. A 3:1 mixture of paint to matte varnish, tinting the paint first by mixing it with oil glaze, gives a high degree of transparency with a delicate, non-reflective finish. The chief difference between this and a straight oil glaze is that any glaze mixed with varnish cannot be rubbed or wiped when it is touch dry, while oil or paint glazes can. Therefore, for a wiping technique you have to use varnish-free glazes, either clear or tinted, and you can use them separately or together. If you use tinted and untinted varnish with a blending technique, lay the clear glaze on to the center of the area and then, with a stippling motion, brush the tinted glaze into it from the edges. On mouldings it is easier to use a single,

tinted glaze, apply it overall, and then rub the glaze off the raised areas with a cloth wrung out in mineral water, leaving the glaze gathered in the crevices. Then stipple it to kill any hard edges. If you use a tinted glaze over a flat area like a table, wipe from the center and blend with a stippling brush toward the edges. If you want a light effect, it is useful to allow the glaze to dry at least overnight, then rub it from the center with fine steel wool, and blend it softly, leaving the edges darker. Then apply a second, thinned coat over that to give it a softer appearance.

The colors used in antiquing wood are similar to those of graining. In almost all cases they are the earth colors – burnt umber, burnt sienna, and lampblack. A black surface is the only exception to this, where the antiquing colors should be dark brown.

RIGHT: Beams here have two coats of thinned, white paint, sanded off to show the wood. Walls have a white distemper and buff wash.

LEFT: A combination of antiquing and colored wash give this chest of drawers a feeling of age. Particular attention has been paid to the vulnerable parts of the piece, especially the edge molding.

ANTIQUING COLOR WASH

Wood to be antiqued by the color wash method must be porous. If the piece has been color washed and needs toning down, the technique can be continued without further ado. If the effect is to be applied to untreated wood, however, the surface must be cleaned with a mild detergent solution to remove any dirt or grease that may mar the finish. When choosing an antiquing color, bear in mind the color scheme of the surrounding area and the color of the piece. The example here uses burnt umber. Although less hot than sienna used with the gold, this color has the necessary warmth to counter the slight coldness of the green ground. The medium can be oil- or water-based. Oil gives more time for application and may, therefore, produce a less patchy effect.

1 Apply the antiquing glaze to the unsealed wood. Brush the color into the pores of the wood, flooding all the flaws and crevices.

2 Use an absorbent cloth to wipe the surface of any glaze not taken in by the wood. Rub quite hard, especially over proud areas, such as mouldings and edges.

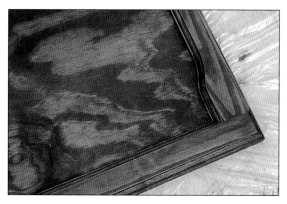

3 The antiquing knocks back the strong green of the color wash, giving an impression of age.

ANTIQUING DRAG

When the piece to be antiqued needs a direction or grain, antiquing drag is often the answer. This finish, achieved in a similar way to dragging, is very subtle. The glaze is applied thinly and must be oil-based to ensure the slow drying necessary for a soft, graded result. The ground color used here is gardenia, and the glaze raw umber. As in standard dragging, the glaze has to move over the surface and, therefore, preparation must be of a high quality.

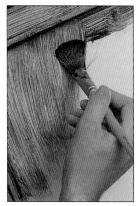

1 Whisk over the surface with a very fine grade of glass paper to ensure that the finish is smooth and without faults that could collect glaze. Remember to sand with the direction of the drag.

2 Apply the raw umber oil glaze, brushing well out and being careful to penetrate every nook and crevice.

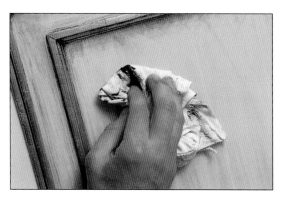

3 Gently wipe the surface backward and forward along the line of the drag with a soft-textured rag.

4 Use a dry paintbrush to tease the glaze that has built up at the ends of the panels.

ANTIQUING HANDLES AND FITTINGS

Probably one of the commonest and most unnecessary sights is an antique piece of furniture with bright sparkling handles. Fittings can easily be subdued by applying a colored glaze, as with woodwork. Boot polish and oak varnish are time-honored treatments that can work to great effect. As a cabinet collects dust of a particular color over the years, the fittings are likely to be dirtied with a similar hue. Glaze can unify the overall task and suggest the effects of use, as well as conveying a patina of age.

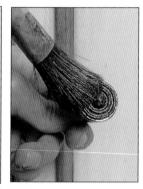

1 The pristine knob prior to its treatment. How inappropriate it would look on a piece that had been toned down.

2 Apply the glaze, making sure that it penetrates the details of the design.

3 Wipe the excess glaze from the surface, leaving it in the recesses.

4 Attach the handles, not forgetting to treat the base roses separately. Stipple on the mixed glaze around the roses, and use the rag and the dry brush to draw the color away from the handles. The finished effect suggests a patina of age where use of the handles over the years has darkened the area around them.

RUBBED ANTIQUING

Although paint effects are normally either applied or subtracted, rubbed antiquing falls into both categories. It consists of two stages: first the removal of paint, varnish, or another applied effect by wire brushing or sanding, and second, the rubbing of glaze into the surface to suggest grime from years gone by.

1 The rather gaudy freshly-painted detail of a chair back.

2 Brush the surface with the wire brush. Don't be too gentle – the odd prominent scar looks authentic. The surface can be scuffed equally well using coarse sandpaper.

3 Apply the raw umber glaze over the entire surface. The exposed areas, being more absorbent, will color more deeply.

4 Rub the surface with the rag, allowing the glaze to remain in the hollows and niches of the piece.

ANTIQUING A CEILING MEDALLION

The texture and moulded surface of this ceiling medallion has been effectively aged and mellowed, creating a patina in only a few hours that would have taken years to achieve naturally. Applied to most surfaces, antiquing will result in an eye-catching finish.

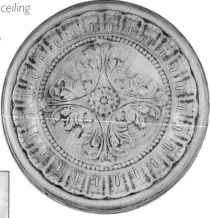

1 Make sure the surface is completely dry and seal it with one or two coats of diluted latex, using the bristle base-coat brush. Allow to dry.

2 With the bristle base-coat brush, apply the base coat, making sure that any intricate carved areas are not missed. Allow to dry for at least 24 hours and then apply a second coat. Allow the surface to dry overnight.

3 On a clean dish, mix a little artists' oil paint (raw umber) with a little transparent oil glaze (follow manufacturer's instructions.) Add a little white spirit to the oil paint before mixing with the glaze to avoid stray pigment streaks later. With mineral water, dilute the glaze until it has a pouring consistency.

4 With the bristle or glazing brush, cover the surface with a generous coat of the tinted glaze. Make sure all moulded and carved areas are covered.

5 While the glaze is still wet, carefully wipe the surface with a soft, lint-free cloth to remove the excess glaze from the raised sections. Do not remove the glaze from the moulded areas. When the glaze builds up on the cloth, use a fresh one.

6 To protect the surface apply a layer of clear acrylic varnish.

RIGHT: Gilding and antiquing transform a plaster accessory into an opulent decoration.

GILDING

Most of us have admired the look of burnished gold on frames and the gilded embellishments on many of our most beautiful buildings. Achieving this wonderfully rich and stunning effect is certainly possible in the home. Just a little gilding here and there throughout the home will add a look of luxury and warmth, and provide visually interesting focal points in any style of interior.

Gilding has been used as a form of decoration for thousands of years throughout the world, from the jewellery of the Incas to the ancient Egyptian's lavish ornaments of death. And, perhaps even more astounding, the methods used have barely changed. Although some types of gilding require much skill and practice, the method described here should prove relatively easy.

The term gilding does not only refer to gold, but encompasses the application of all metal leaves and powders, from silver and platinum to bronze, aluminum, and gold-colored alloys.

The ancient process of gilding can be thought of as one of the earliest faux finishes because the intention was to convey the impression of solid gold in a less costly structure covered with only a thin skin of precious metal. The problem, therefore, is how to glue this fine sheet of gold or other metal to the surface, having previously ensured that the surface is exquisitely prepared, often with the use of gesso.

OIL- AND WATER-BASED

Traditionally there are two varieties of true gilding. As with many paint effects, these are water-based and oil-based.

Water gilding is highly delicate and can be ruined by dampness. It is also a far more difficult technique than oil, involving only water with a minute addition of glue as an adhesive, and it cannot be used with transfer leaf. Oil gilding – also known as mordant gilding – is therefore recommended here. Apart from being easier to undertake, it is much more adaptable and less vulnerable.

GOLD SIZE

The glue used in oil gilding is called gold size. This is a special mixture containing linseed oil, a drier such as lead oxide, and copal varnish. Turpentine is often added as a thinner to ease application. Sizes are often quoted in terms of their drying time: four-hour, eight-hour, or sixteen-hour size, for example. Drying time is important because the quicker the surface dries the less danger there is from dust or other pollution, but the slower it dries the more time you have to work and the better the gleam. "Quick Japan size," that dries exceptionally fast – in one to two hours – is useful where the atmosphere cannot be controlled and dust particles may fall in the wet size, but it is correspondingly fragile and more prone to cracking.

As always, a balance must be found, but above all it is essential to keep the atmosphere as clean as possible. Pieces that are small enough can be covered. Do not wear wool, and keep draughts to a minimum. Paint the size on evenly, or drying will be patchy and affect the adhesion of the leaf.

When gilding over gesso, it is wise to coat the ground with one or two coats of thinned shellac. This seals the porous gesso and reduces the risk of a patchy gold size coat. If you use acrylic gesso, you may not need a shellac coat.

APPLYING GOLD SIZE

The area to be sized must dictate the shape and dimensions of the brush. Flat brushes are suitable for large areas and mouldings; round brushes are better for carvings and intricate details. The brush should be of good quality, with long bristles to hold the size, yet firm enough to lay out the size evenly. Do not apply the size directly from the can. It must be decanted into a clean paint kettle or other container with a wire or thread tightly strung across the top. This strike wire will cause the size that is wiped clear of the brush to drain back into the container without forming bubbles. Only decant the amount of size needed for the job. More can be added if need be, but once the size has been decanted it should never be returned to the original can, that is still clean and dust-free. Before any application, wipe the surface to remove any remaining dust.

WHEN TO GILD

Once the size has been applied, the temptation to begin gilding is very great. However, if the gold or metal leaf is applied too early, it remains vulnerable to marks because the size underneath is still soft. What's more, the leaf will be dull and lifeless. The correct time to gild is when the size is practically dry. It is often suggested that you test this by drawing the back of your hand or finger gently over the surface to produce a squeak. This can be useful, but if you try it too early, you may cause serious damage. Another sign used by some is that the size begins to lose its glossy texture when it is ready for gilding.

SIMPLE GILDING

1 Apply a base coat of your preferred color. Allow to dry thoroughly, and apply a second coat.

2 Stipple some water-based gold size through a suitable stencil, or hand paint your design in gold size. Allow to go finger-touch dry.

3 Prepare some pieces of gold leaf or Dutch metal, and apply them carefully to the size.

4 Press gently on the transfer paper with a soft cloth to smooth out the leaf or Dutch metal. Allow to dry completely.

5 Remove the backing paper, and carefully brush away the excess with a very soft brush.

6 You can delicately distress the surface, if you wish, with fine steel wool, allowing the base coat to show through. Protect with a gloss varnish.

GILDING WITH POWDER

Metal powders range from rich pale gold to dark bronze. Aluminium powder is also available. Their application is best achieved in a draught-free environment. When working with any fine-ground powders, it is advisable to wear a mask. This protects the lungs from contamination and lessens the possibility of breathing on, and therefore dispersing, the powder. Apply the gold size in the same way as with loose leaf, and allow it to wipe off. Use a camel-hair or squirrel-hair mop to work the powder over the size and into any crevices. Allow the surface to dry for at least an hour before removing the excess powder with a soft cloth. Powder effects are liable to tarnish, so protect the surface with a coat of oil-based varnish.

1 Apply the gold size and allow it to become tacky.

2 Cover the sticky size with the dry powder, using the soft-haired mop to work it into all the details.

3 When the size has dried for at least an hour, gently remove the loose powder using a soft duster or rag.

4 It is advisable to varnish gold or bronze powder, because it tends to varnish.

GILDING WITH GOLD PAINT

This technique is often used to add details to a piece, such as a line or a small hand-painted design. The gold paint can be bought, or you can mix your own using bronze or gold powder and either gold size or a water-based glaze. Whether your medium is oil- or water-based, you will need to make a smooth, free-flowing but strong solution. If the mixture is weak, the gilding will be dull and lack definition. Apply it with a brush.

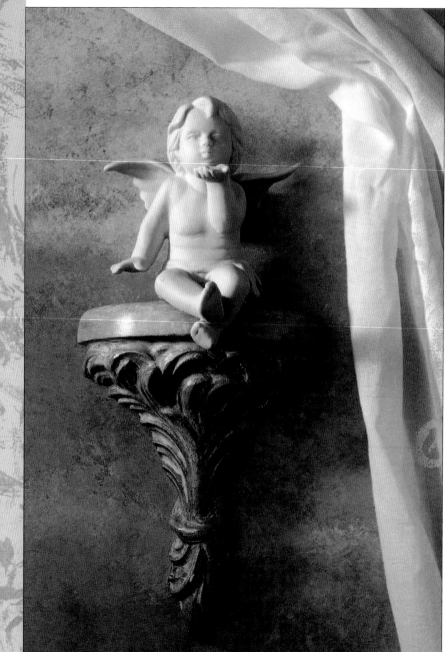

VERDIGRIS

The name verdigris comes from the French vert de Grèce (green of Greece) and denotes the color of age. Verdigris is actually a coating of cupric carbonate, formed by atmospheric action on copper, brass, and bronze. The beautifully aged and weathered patina of verdigris can conjure up visions of old brass, and of bronze and copper statues brought up from the bottom of the ocean. Creating this timeless effect is an absolute pleasure when applied to such pieces as plaster busts, candlesticks, boxes, and ornaments. It can also be used to great effect on larger areas such as cupboard doors, table tops, ceiling ornaments, and dado rails.

VERDIGRIS PLASTER SHELF

This shelf would look great in an entryway or sunroom. It only takes a few moments to create this treasure, but no one will know how easy and inexpensive it was to complete.

1 Seal the plaster with sealer and let it dry. Using a ¹/₂ in. (1 cm) brush, apply a blue–green acrylic base coat and allow to dry.

2 Apply an even coat of adhesive over the shelf, being careful to get into all the crevices. Let it dry until it is no longer a milky color, then apply another coat of adhesive. Set aside to dry until the adhesive is clear and sticky to the touch.

VERDIGRIS PLASTER SHELF (continued)

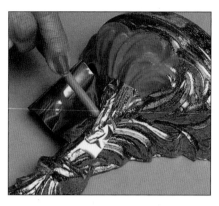

3 Cut the verdigris copper foil into small, easy-to-use pieces. Holding it so the shiny side is up, press the foil firmly over the adhesive. Use a pencil rubber, cotton swab, or the wooden end of a brush to press the foil into the crevices. Allow some of the blue-green base coat to show here and there. Apply a thin coat of sealer over the entire shelf and let it dry completely.

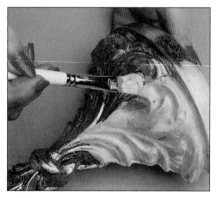

4 Brush the antiquing provided in the kit over the shelf, again being sure to get into the crevices. Let it dry a little before proceeding to the next step.

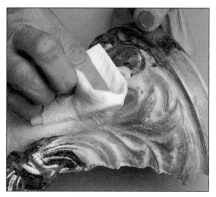

5 Wipe away the antiquing with paper towels or a soft cloth. If you wipe away more than you would like, repeat step 4 and wipe again. Use a damp towel or cloth if the antiquing has become too dry to remove easily. When you are happy with the results, protect the finish by brushing on a coat of sealer or satin varnish.

VERDIGRIS EFFECT ON WALLS

Paint is a simple and inexpensive way of enhancing the walls of our homes. By following the step-by-step instructions below, you could soon enjoy the beauty of verdigris in any room of your choice.

1 Paint onto your surface two coats of water-based gold acrylic paint, and allow to dry. Dab onto the base coat patches of bright green, white, and a little aquamarine blue.

2 Use a stippling brush, gently stipple the three colors together to create that typical verdigris patina.

3 While the paint is still a little wet, remove some areas with a lint-free cloth, allowing parts of the gold base coat to show through.

MARBLING

M arbling is one of the most popular of the faux finishes simply because it can be used to create so many spectacular effects. Sienna is the most copied marble and is therefore one of the most popular to incorporate into different decorative schemes.

Marbling dates back to ancient Egypt, and is said to owe its evolution to the high cost of the genuine material and the difficulty of transporting it over large distances. However, the art spread, even in countries such as France and Italy, where marble was easily available. The reason probably lies in the nature of marble itself. A strong compacted stone, it is a safe building material when used in a block or column. But it cannot be used for beams and ceilings. These would therefore be decorated with the faux finish to complete a marble room scheme.

Similar techniques were also employed in a purely decorative way to create pleasing marblelike effects without regard for authenticity. This fantasy marbling, known today as marblizing, was used in harpsichord cases and other situations where it would obviously be impossible to use the true material. The techniques shown on the next few pages have been passed down over many years specifically to produce imitations of real marble. But skills you acquire while practicing these effects can equally well be used with any color combination you like to produce a marblizing effect.

BELOW: The fantasy marble on this doorframe creates a warm and lavish look – fun and slightly theatrical.

SIENNA MARBLE

This marble is warm and delicately figured, and lends itself to use on walls and baseboards, or furniture.

The ground

1 Evenly apply the white undercoat tinted with raw sienna.

2 While the ground is wet, lay on patches of burnt sienna tinted glaze.

3 Add some similarly sized patches of vermillion tinted glaze.

4 The raw sienna tinted glaze completes the tri-color combination.

5 Use the lint-free rag to blot the wet surface.

SIENNA MARBLE (continued)

Softening

1 Soften the ground colors with the hog-hair softener. This technique is worked in four directions – north, south, east, and west. Here the brush is being gently drawn to the south. The bristles should barely touch the surface, and the brush should be angled slightly toward the direction in which it is traveling.

2 The brush must be kept clean throughout. Rub it onto a clean, dry rag before you soften the ground to the north, and repeat the cleaning every time you change direction.

3 Soften in an easterly and then a westerly direction, remembering to clean the brush constantly.

4 If the brush is used too strongly, brushmarks will appear. This can be corrected by cleaning the brush and brushing lightly at right angles to the mark. Here the final softening strokes are being applied. Compare the appearance of the ground now to the way it looked at the start of softening.

Veining

1 Using the sword brush dampened with white spirit, pick up some blue-black, and draw the major veins quite quickly. Always pull the brush toward you, and change direction by twisting it between finger and thumb. Here a forking vein is drawn, broken by the kind of crack that is typical of marble.

2 Soften the veins in the same way as the ground colors, but this time using a badger-hair softener. The finest of all brushes, this will soften so delicately that the subtleness achieved is breathtaking.

3 Using a natural marine sponge slightly dampened in white spirit, gently dab over the ground. This technique causes the ground to burn through in places and creates a freckled effect that contrasts well with the smoky softness of the other areas.

4 Soften the sponged areas following the same technique as before, brushing the slanted hog-haired softener gently to the north, south, east, and west.

5 Use the sword brush to apply patches of white undercoat. These should be bounded by a vein as shown.

6 Soften with the hog-hair brush, first along the vein, then gently away from it, and finally back toward the vein. In this way, the chalky deposits appear to be held back by the veins.

7 Draw in the finely cracked and splintered secondary veins, using the sword brush and blue-black.

SIENNA MARBLE (continued)

9 Use white undercoat for additional veining detail and to highlight veins and cracks.

8

10 The completed Sienna marble should be varnished when dry to protect and enhance the delicacy of the effect.

8 These cracks form on every bend of a vein, and fracture forward as well as backward, creating a fine weblike network. The crack shown in the first veining pictures appears here in greater detail, and has led to further crazing, which stops only when it joins the next main vein. This type of structure is common in marble, where veining results from enormous changes in temperature and pressure.

10

EGYPTIAN GREEN MARBLE

This rich dark green marble is often used on pilasters and plinths, but its intricate detail and luxurious quality make it appropriate for smaller items such as tabletops and inlays. The effect begins with a black ground, which should be smooth and dense.

Initial effects

1 Using a toothbrush or stencil brush, spatter the vermillion glaze onto the black ground and allow to wipe off.

2 Twist an artist's writing brush between finger and thumb to roll the terre verte glaze onto the ground.

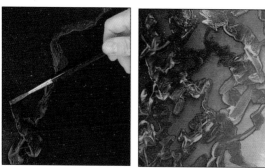
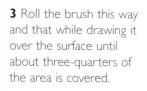

3 Roll the brush this way and that while drawing it over the surface until about three-quarters of the area is covered.

4 Soften the effect by crushing some newspaper into a pad and working over the surface as if you were sponging or ragging.

EGYPTIAN GREEN MARBLE (continued)

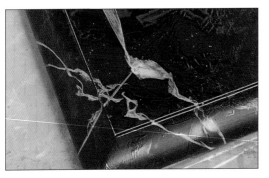

Veining

I While the ground is still wet, apply a white under-coat thinned with white spirit or turpentine substitute, using a sword brush. Again, roll the brush between finger and thumb, and use its flat, tapered shape to produce wide and narrow vein lines. Make all your painting strokes toward the body, bringing the width and the heel of the brush into play when a broad vein is required and the tip and edge of the brush for a thin vein.

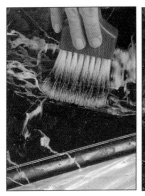

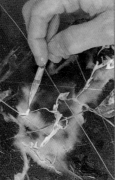

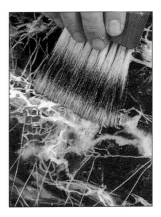

2 When the initial veins are in, soften them with the badger brush. The softening gives a smoky effect, and creates the illusion that the vein is a little way under the surface.

3 Add more veins, like this one, sketched over the top of an earlier vein. The meandering veins of this marble differ quite strongly from the patterns found in the Sienna marble.

4 More softening follows, and you can see the gradual build-up of fine, straight crack veins that run at right angles to the original trend.

Softening

1 Some of the small plates created as the white veins break up the surface are picked up with vermillion from a fine artist's brush.

2 Soften the vermillion plates using the badger-hair brush. As always, softening is crucial to successful marbling. The bristles should hardly touch the surface.

3 Only a clean brush will produce a good quality finish. Clean the bristles regularly with a dry rag.

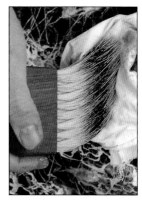

4 The completed surface showing the swirling, frothy network of veins intersected by fine lines. Allow this to dry before varnishing. Varnish enriches the shading and preserves the texture of the finished effect.

PORTORO MARBLE

One of the most striking and definitely the boldest is the black and gold marble commercially referred to as Portoro marble. It is an effect that is so striking, and so rich in texture and depth, that it can add a feel of extravagance to both modern and traditional rooms.

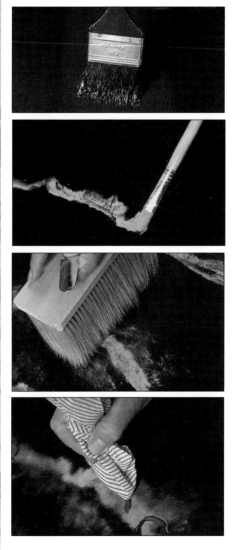

1 Prepare the surface. Apply an undercoat and allow to dry. Then apply two coats of black eggshell paint. Allow at least 24 hours drying time between coats and before commencing the next step.

2 Clean surface with tack cloth. Mix some gilp and apply an even coat. Using a ¹/₂ in. (1.2 cm) Fitch brush, squiggle some yellow ocher artists' oil paint on the surface in a roughly parallel, veined pattern. Vary amount in each vein.

3 With a stippling brush carefully stipple out the veins creating a very cloudy but uneven effect within each vein. Work on one or two veins at a time, making sure that each continues across the surface in a random pattern. Soften with a badger softening brush.

4 Using an unsharpened pencil or an eraser wrapped in lint-free cloth, work along each vein, rubbing out oval sections to form a chain-link pattern. Use a clean piece of cloth each time. Soften edges with a badger softening cloth. Dry.

5 Apply a fresh layer of gilp. Mix white artists' oil with white spirit to increase the flow. With a Fitch brush create white veins by squiggling the brush across, between, and over the ocher veins. Stipple, soften, and dry.

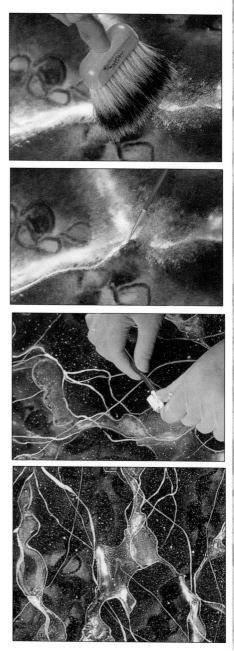

6 Mix some artists' white oil paint with mineral spirits to a pouring consistency. With a fine swordliner brush outline ovals and sections of the softened white veins. Overvein the surface with more white veins by pulling the lining brush across the surface. You can use a feather for this. Allow to dry.

7 Carefully spatter the surface at random with some white oil paint slightly diluted. Do not dilute too much, as the paint will only form unsightly puddles. Allow to dry. Varnish with a least four coats of oil-based gloss varnish. Smooth down the last two coats with wet-and-dry sandpaper between coats to help achieve a glasslike finish.

8 Marbles are always attractive, displaying depth and movement in a natural way. Here, a very striking effect is achieved using black and gold (ocher). The web of veins both on and below the surface creates an effect of stunning beauty and individuality.

CRACKLEGLAZE

Crackleglaze is an effect ideally suited to all sorts of woodwork, from decorative items such as lampbases and boxes to chest-of-drawers and architectural features such as doors, baseboards, and window frames. You may wish to apply crackleglaze to walls, but remember that although the effect is very pleasing, it can look a little overwhelming when used on large areas that would not normally be prone to flaky or weathered paint.

CRACKLEGLAZE ON TONGUE-AND-GROOVE PANEL

The weather affects nearly everything in one way or another, and nothing more so than painted exterior woodwork. Using crackleglaze you can create the wonderfully tactile effect of cracked paint in your own home.

The crackleglaze medium is available in good decorator stores, but it does take a little practice. All manufacturer's instructions should be strictly adhered to. The most common pitfall is to overbrush the topcoat, causing a break up of the cracked effect. If repainting is needed, allow the topcoat to dry, then carefully paint in any areas previously missed. Otherwise remove the whole surface by washing with water, allow the surface to dry, and begin again.

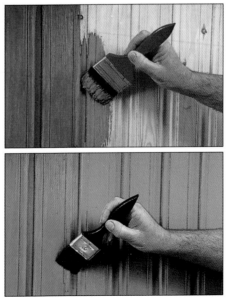

I Fill all holes and sand to a reasonably smooth surface. Remove all dust with a damp cloth. Apply two base coats of peacock blue simulated buttermilk. Latex may be used, but check with the manufacturer's instructions of the crackleglaze being used. Allow to dry overnight.

2 Apply a generous layer of the crackleglaze medium with a 2 in. (5 cm) bristle brush, avoiding unsightly runs. Make sure the join between each panel in the tongue-and-groove is covered. Allow to dry.

3 Apply a layer of yellow ocher simulated buttermilk paint with a 3 in. (7.5 cm) bristle base-coat brush. Paint vertically with the ridges of the paneling. Make sure that the paint gets into the grooves. Do not overbrush.

4 Apply at least two coats of varnish to protect the surface. If you have chosen a hard finish, varnish with at least two coats of an oil-based varnish. Acrylic varnish may be used but be careful not to overbrush and start the cracking reaction again. Furniture wax may also be used.

5 If overbrushing happens, the glazing medium and paint tend to mix into very unsightly patches. The surface becomes sticky and unmanageable, and can only be repaired by sanding. Completely remove the surface and start again.

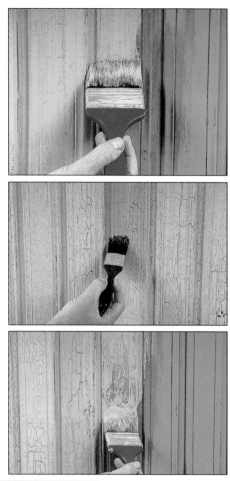

6 The tongue-and-groove paneling used here is brought to life by the use of warm ocher over peacock blue-green, two colors that work very well with each other.

STENCILING

The art of stenciling can be traced back some 3,000 years or more, and is still an excellent way of creating a coordinated decorative scheme in one room or throughout the home. By designing your own stencil, you can introduce an element that adds a personal touch to a room or piece of furniture.

A major advantage of decorating with stencils is that the tools and materials required need not be expensive. It is a craft where you can gradually build up your equipment as you need it, and if you are prepared to design and cut out your own stencils not only will you have the satisfaction of producing your own designs, but there also is a considerable financial saving involved.

Additionally, be inventive with household materials such as kitchen sponges for applying paint. Try tying string around a foam roller so that the finished effect is mottled rather than flat. Keep empty yoghurt jars to use as disposable containers for paint and varnish. Clean your brushes by rubbing the bristles across the rough surface of nylon pot cleaners. Save old tights for sieving lumpy paint and use old T-shirts for ragging on paints.

CUTTING A STENCIL

1 Trace out the design, leaving the ties in position.

2 Turn the completed tracing over onto the stencil card, and re-trace.

3 Place the card on the cutting mat, and use the stencil knife or craft knife to cut the stencil out, always working toward the body.

4 Registration marks should be made on the original tracings. This is especially important in the case of a double stencil, so that the design can be aligned on the surface.

5 Transfer the registration marks to the stencils by overlaying the tracings and remarking the points. Make these into a small hole or notch through which you can make a pencil mark to line up the cut stencils.

APPLICATION TECHNIQUES

Once you have positioned your stencil as you want it, then you need to tape it in place with decorator's masking tape. If you do not tape it down there is a risk that it will slip while you are applying the paint, or that it will not lie flat and you will not get a sharp edge to the design.

Flat Brush

A flat decorating brush can be used instead of a stenciling brush to apply an opaque layer of paint. It is effective for quickly applying a strong-colored ground as a base for a metallic color, such as deep vermillion under bronze. When using a flat brush, take care not to let the bristles get caught under the stencil edges.

Sponge

Sponges are useful for achieving various effects, from chainlike threads of color to blending two or more shades into a wash. Natural sponges tend to leave more pronounced marks than synthetic versions, and are useful for producing faux stone effects. The imprint is a series of open spaces linked by an organic, threadlike structure.

APPLICATION TECHNIQUES (continued)

Stencil Brush

The standard method of applying paint with a stencil brush, sometimes known as pouncing, uses fast dabbing movements, almost like hammering with the brush. The pouncing action creates an even, softly stippled effect. Avoid too heavy an application of paint. The density of color can be increased if it is too light, but it can't be taken away, so just put a tiny amount of paint onto a barely damp brush, and work the paint into the brush before stenciling.

Fabric

All manner of textured fabrics can be used to create interesting finishes. The weave on this particular cloth produces an attractive woolly effect.

Spray paint

Spray paint is useful when you are trying to cover a large area. Once you have taped the stencil in place, mask the rest of the area with card or newspaper to protect from overspray. You can create different effects with spray paint by varying the density of spray.

USING GRIDS

To stencil a repeating design, you will need to mark out a grid. This will help you position the stencils accurately, and will save you time in the long run. The grid is made up of perpendicular lines, either horizontally and vertically (forming squares) or diagonally (forming diamonds). Be sure to measure accurately when marking out the grid, and check when you are drawing the lines that they are exactly at right angles to each other (a carpenter's square or even a CD case or a book will help).

1 For a grid of squares, mark points at the desired spacing along all four sides of the surface. They should be no farther apart than the length of your yardstick, so if necessary mark intermediate points too. Using the yardstick, join the marks with straight lines.

2 For a grid of diamonds, mark out a large square area, and draw straight lines between diagonally opposite corners. Draw your grid lines parallel to these, the desired distance apart. Extend the lines beyond the square area as necessary to fill the entire surface.

STANDARD STENCILING

A standard stencil is normally applied with a stubby stencil brush of the appropriate size, loaded with thick water- or oil-based color. Test the print first on a spare piece of card. The drier the print, the less danger there is of seepage. Steady the stencil plate with masking tape to ensure a clean print.

1 Secure the stencil in position on the surface, with masking tape.

2 Load the brush with color, and check the print on some card or a spare area of stencil. Place the brush onto the perforated portions of the stencil, angling the brush to make sure all exposed areas are covered. Occasionally, a bristle may creep under the stencil, but this merely adds to the charm of the effect.

3 Use a soft pencil to mark the surface through the registration notch or hole.

4 When the first stencil print is dry, use the registration marks to place the second stencil in position, and secure it with tape.

5 Apply the second color through the stencil as before.

6 A more detailed view of the completed two-color stencil shows how the color can sometimes overlap.

STENCILING WITH A SPONGE

A sponge produces a cleaner print than a brush. The flat side of a synthetic sponge will provide a uniform mark, and a more dappled undulating print will be obtained from a marine sponge or the torn face of a synthetic sponge. Sponges need a thinner paint or glaze than brushes to allow for some absorption. Greater care must therefore be taken to prevent this thinner color from bleeding under the edge of the stencil and spoiling the effect.

1 Tape the stencil into position and gently sponge the color over it. Having covered the area once, go back over it again to make sure that small details are not missed.

2 Compare the cleaner outlines of the sponged stencil with the previous brushed effect.

TRACING

Tracing fits in very well with both modern and period settings, and can be used on plates and tiles as well as on intricate picture frames. Although the example shown here is in blue and white, any color combination may be chosen, depending on the mood and style of the required finished effect.

1 Measure the area to be covered by your image and have the chosen images either reduced or enlarged to the required size on a photocopier.

2 Distress the surface. Here the surface was painted in navy blue eggshell, left to dry, and a layer of white eggshell applied. It was then heavily distressed with a medium- and a fine-grade sandpaper to let the paint and natural wood show through.

3 Measure the area where tracing is to be positioned. On stenciling card or acetate draw an oval shape with a permanent marker pen and cut out with scissors. This will be used as background to the tracing. Measure the tracing to make sure it will fit.

4 Apply a little spray adhesive to the back of the stenciling card or acetate and place it in position. Using the stencil brush and some artists' white acrylic or white stencil paint, stencil the oval onto the door panel. Allow to dry.

5 Fix a suitably sized piece of carbon or tracing paper with a little tape to the back of your tracing, ink side facing out. Carefully place the tracing and the carbon paper in position over your stenciled panel. With a sharp pencil methodically and slowly trace around the image to be transferred. Check intermittently that nothing has slipped and that the lines are clear and correct.

6 Once you are satisfied that the tracing is complete, carefully remove the tracing and the carbon paper. Pour some navy blue artists' acrylic paint into a clean container. Add a little water to achieve a smooth, heavy cream consistency. With a fine artists' ox hair brush, slowly paint in all the traced areas. Allow to dry. Apply a layer of wax or varnish for protection if required.

7 The blue and white colors of Delft china have been used here to create an Asian theme for this door paneling. Because the image is traced, high quality results can be expected. Aged and distressed, the image becomes more romantic and illusory, reliving the charms of bygone eras.

MOSAIC

Many beautiful and intricate mosaics have been discovered among the ruins of ancient cities in countries such as India, Italy, and Greece. They are very expensive to produce from the semi-precious stones, marble, and glass that were originally used, but now it is possible to achieve the same effect using paint.

Mosaic is an inexpensive technique and allows for an imaginative use of color. It can look quite beautiful in period and modern settings, and mixes well with old and new accessories. It is best to employ this technique where mosaic could possibly be used in reality. The effect is ideal for kitchens and bathrooms, where it can be applied to walls, furniture, and floors.

1 Prepare the surface. Apply an undercoat and allow to dry. With a 2–3 in. (5–7.5 cm) bristle brush apply two coats of pale blue semigloss vinyl silk latex. Dry between coats before starting the next step.

2 With a permanent marker pen draw your design onto a sheet of stencil card (oiled manila board). With a sharp craft knife, cut out the design. Keep the cut-out shapes and the piece of card.

3 Cut out 1 in. (2.5 cm) squares of vinyl flooring, foam-backed carpet, or squares of cut-out carpet using a craft knife, a metal straight edge, or some sharp scissors.

4 Cut some lengths of wood into 2 in. (5 cm), 4 in. (10 cm), and 8 in. (20 cm) lengths. With a ¹/₂ in. (1.3 cm) bristle brush and some PVA glue place the squares of foam along the length of the pieces of wood. Space the foam pieces evenly. Ideally you should produce a single-pad stamp, a double-pad stamp, and a six-pad stamp.

5 Apply a little spray adhesive to the back of the cut-out stencils and place in position. Apply some pale cream latex to the squares using the block you find easiest to control. Press the pads across the entire surface, background, and stencils. To create stripes, change the paint color. Allow to dry.

6 Remove the cut-out stencil and replace it with the positive image. Apply some navy blue latex paint with the single or double stamp and stamp across the cut-out area to complete the mosaic effect. Let dry. Apply two coats of clear acrylic varnish, waterproof and non-yellowing.

7 The colors and wonders of the ocean have been recreated here in a timeless, traditional, and interesting way. The mosaic effect adds that little bit of extra magic to this bathroom wall. Fun and challenging to do, this technique can be applied to any surface.

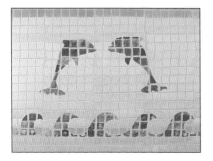

AGED TERRACOTTA

The results of many years' exposure to the elements can lend age to natural terracotta, giving it a beauty that conjures up visions of tiled floors in country kitchens, or the beauty and timelessness of some historic homes.

This very simple plaster corbel has been given a finish that once could only have been achieved from years of exposure to the effects of rain and sun. Moldings, cabinet doors, floors, and walls can all be given this aged romantic feel quickly and effectively.

1 Make sure the plaster is dry. Seal the surface with diluted semigloss vinyl silk latex diluted to a light cream consistency. Allow to dry. Any chips or flaws in the surface of the plaster will enhance the final appearance.

2 Using a 1 in. (2.5 cm) bristle base-coat brush apply two coats of pale terracotta eggshell to the surface. Dry between coats. Some of the base coat can show through if desired, to give a variation in the final surface color.

3 On a clean plate mix some transparent oil glaze with some artists' viridian oil paint tinted with a little yellow ocher. You may need to add a little white spirit to make a creamy consistency. Add a little sand or sawdust to the mixture to create texture.

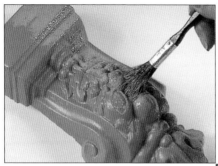

4 Using a ¹/₂–1 in. (1.3–2.5 cm) bristle brush, stipple the glaze over the surface, making sure that it totally covers all the awkward areas.

5 Allow the glaze to become tacky (this should take about 5 to 10 minutes), then wipe the surface with a clean, lint-free cloth or paper towel. Replace the cloth or towel often as you remove excess glaze. Keep the build-up of glaze in the carved areas and highlight the raised areas. Dry.

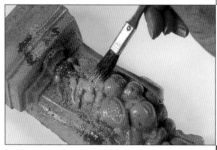

6 Mix a little yellow ocher with some white spirit and brush lightly into any recessed area using a ¹/₂ in. (1.3 cm) bristle brush. Be careful not to overdo it as the entire look can be destroyed by overworking the colors.

RIGHT: This quarry-tile effect floor was produced using stenciling, colorwashing, and antiquing. Over a base coat of cream, the "octagonal" tiles were stenciled in dark terracotta, which was then filled in with a smaller square stencil using cream acrylic paint. Once dry, colorwashing glazes of white and olive green were added. It was finished by waxing with clear wax tinted with burnt umber powder color.

STAMPING

Stamping as an effect can produce a wide range of eye-catching results, and when used in conjunction with a technique such as colorwashing, it can create a relaxing and peaceful interior. Because you make your own designs, you can be as imaginative as you like, to create a truly unique and individual finish.

Stamping is a very inexpensive technique, requiring only a little time and practice to produce many different patterns and effects. Stamping can be applied to any flat surface, the most ideal surfaces being walls, ceilings, and floors. The choice of colors is endless, and you are limited only by your imagination. Once you have planned out and marked the positions of your stamp, completing a room can take comparatively little time, but remember that being too hasty can result in mistakes.

MAKING YOUR OWN STAMP

I With a fine permanent marking pen and a ruler, transfer your chosen design to a piece of foam-backed carpet. Make the outside measurements of the design slightly smaller than the block of wood to be used in Step 4.

2 With a sharp pair of scissors or a craft knife, slowly and carefully cut out all the shapes that will be printed in the final design. Throw away unwanted pieces to avoid confusion. Make sure that each shape of the design is cut out as evenly as possible.

3 With a ruler and a sharp pencil, draw the design onto a smooth block of wood or medium density fibreboard. Make sure to keep the outside measurements the same as for Step 1.

4 With a ½ in. (1.3 cm) brush and some waterproof glue, paste the foam shapes onto the design on the wood block. Apply the glue to the outer edges of the foam pieces to avoid curling. Carefully position each section and watch that no sliding occurs before the glue has time to dry.

5 With a ½ in. (1.3 cm) bristle brush cover the surface of the printing block with paint. Apply the paint evenly and clean up any runs with a cloth.

MAKING YOUR OWN STAMP (continued)

6 Stamp the block onto clean paper to remove excess paint before starting. Slowly and evenly press the block onto the surface. Be firm but do not apply excess pressure or this will cause the paint to squeeze out over the edges of the pattern. Remove the block quickly and evenly. Continue as required.

7 Stamping, whether using a store-bought design or making your own, allows you to create a look that is totally individual. Here the vivid yellow has transformed this wall. Stamps are fun to create and enjoyable to experiment with, and stamping is only limited by your imagination.

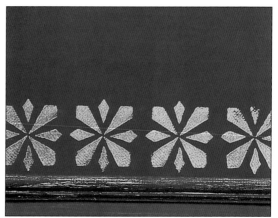

EMBOSSING

Embossing is a very simple technique with extraordinary results. For embossing you will need a heat source and embossing powder. While your image is still wet, pour embossing powder over it and then shake off the excess. Heat the powdered image until the powder melts; this should take approximately 15–20 seconds depending on the intensity of the heat. Avoid overheating as this will make the image appear flat and waxy. As soon as all the powder has melted the process is complete.

TORTOISESHELLING

Tortoiseshelling is an expensive finish to create and is therefore better suited to smaller, decorative pieces such as lampbases, wastepaper bins, or the umbrella stand shown here. It is not an easy effect to achieve, and practice on a sample board is highly recommended before attempting larger areas. As with marbling, it is a good idea to study some pictures of real tortoiseshell before attempting the effect, in order to get a feel for what it looks like.

RIGHT: Tortoiseshell was frequently used by the Victorians to decorate a whole range of household items. It is possible to achieve a realistic copy using only paints and varnishes. Here, on this umbrella stand, a natural red base color is used, but a strong yellow is just as attractive.

ACHIEVING THE TORTOISESHELL EFFECT

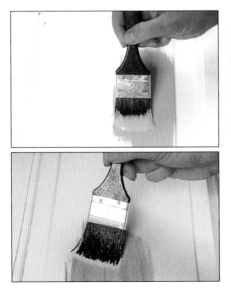

1 Prepare the surface and apply a base coat of pale ocher eggshell paint with a 2–3 in. (5–7.5 cm) bristle brush. Allow to dry overnight. Sand down with fine sandpaper. Remove all dust with a damp cloth, then apply a second coat. Allow to dry.

2 Pour some oil-based varnish into a container and tint with a little raw sienna oil paint. Mix enough to complete the job. With a 2–3 in. (5–7.5 cm) bristle brush apply a layer of the varnish to the area being tortoiseshelled. Work quickly and evenly on an easily manageable area.

3 In three separate clean dishes pour raw sienna, burnt sienna, and raw umber artists' oil paints. Thin with varnish. Using a Fitch brush dab dots of the paint across the surface in a roughly diagonal direction. Do not mix the colors. Use a clean brush for each color.

4 Carefully drag a long-bristled dragging brush diagonally across the surface in smooth, clean strokes. Repeat by cross dragging at an angle of 90 degrees. Be careful not to overdo the dragging, which will remove the spotty texture of the tortoiseshell. Add more dabs of paint and repeat the dragging until you have achieved the effect required.

5,6 With a badger softening brush carefully soften the entire surface, removing all brush strokes as you work. Work very gently, only just touching the surface. Allow to dry.

With a varnishing brush apply at least four coats of oil-based varnish brushing in one direction only. Carefully smooth down the surface with wet-and-dry sandpaper between the last two layers to remove any imperfections in the final finish.

7 This is an exotic effect that creates a really beautiful and unusual result. Rich and sumptuous, the possibilities for its use are endless. Carefully chosen colorways can make it an attractive addition to any decorative scheme.

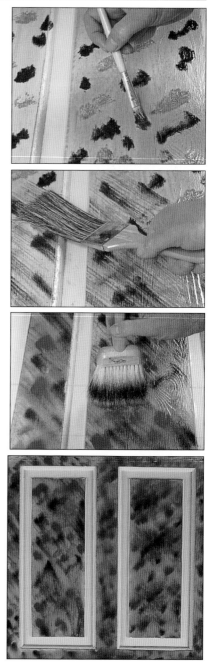

SUGI

his charred wood effect dates back to the 15th century, when Eastern craftworkers used it to mellow and
lend the impression of age to a piece. Their technique, which is still employed today, involves the skillful
playing of a flame over the surface of the wood. However, this alternative paint effect can produce a similar
effect without the danger of using a naked flame. The piece being treated should be made of timber, or at least
veneered with a wood. The surface should be clean of any other finish, and may require stripping.

The first stage is to stain the wood, using a black, oil-based stain. An oil-based stain is easier to apply
than a quick-drying spirit stain, and penetrates the wood less. Put the stain on thinly with a brush and don't
worry about a patchy covering. Now follow the easy step-by-step instructions below.

1 Rub the fine surface
filler into the grain of the
previously stained wood,
using a circular motion.

2 Pull the filler across
the grain with a scraper,
allowing it to fall into the
pores of the wood. Leave
to dry.

3 Using a medium- to fine-grade silicon carbide paper, sand with the grain, removing the surplus filler and (in places) the stain. Wipe over the piece occasionally with a damp rag to check how much stain has been removed.

4 Varnish the piece using a varnish brush, and allow to dry.

5 The addition of black latex spatter can complement the effect.

TROMPE-L'OEIL

The French term, literally translated, means "tricking the eye," and this is a technique artists have used since ancient times to do just that – create the illusion of three-dimensional space on a flat surface. In Roman times, for example, building methods meant that walls were thick and windows narrow, so there were large areas of interior wall to be decorated. Vistas were painted to "open up" the dark, enclosed interiors with an impression of light and space. Skilled artists through the ages have continued to produce stunning effects, but even the simplest trompe-l'oeil can transform a bland surface or introduce a note of humor. It is easy to become so excited by the possibilities of this effect that you immediately want to seize the brush and paint a scene on a wall or some shutters. But, the most effective trompe-l'oeil is so subtle that it is almost imperceptible, and this type of understated effect is your best starting point.

The manipulation of light and shade is essential to trompe-l'oeil. The light source must first be set and shadowing carefully painted in. It is this, together with foreshortening, which will give the feeling of depth. Choose a simple design with mostly straight lines, such as geometric paneling, and decide where it is to go. Prepare the ground well by cleaning it and keying it in lightly ready for paint. Determine the size of your design and use a pencil and straight-edge to draw it. Choose a master color for the flat areas, and a lighter and a darker version of this to indicate highlights and shadows. When mixing these two shades, err on the side of subtlety. It is always easier to add definition than to take it away.

1 Work out the size of your panel and draw it, using a soft pencil, a straight-edge, and set square.

2 The completed drawing, together with the equipment used in its drafting. The mitered corners contribute to the impression of depth that will be reinforced by the paint.

3 Use an angled fitch to apply the mid-tone, or master, color to the center of the panel and the area outside it.

4 At this juncture, it is important to determine where the major source of light is positioned. In this case, as the completed effect shows, the light is striking the frame from the top left-hand side. This places the upper and the left-hand sides of the thin molding in shadow, while their neighboring wide molding catches the light. The opposite tonal effect is created in the lower and right-hand sides of the panel. Here, the pale tone is being applied to the thin outer molding which will form the bottom and right-hand edges of the finished panel.

5 Complete the areas of lighter tone before applying the darker shadow. Here, the darker tint is painted onto the wide molding at the bottom right-hand side of the panel.

6 The completed effect with light coming from the upper left of the picture. Notice that when molding catches the light, its neighboring plane falls into shadow. This play of light and shadow using closely-related tones of color is the key to *trompe-l'oeil*.

RIGHT: Here, the high, three-dimensional effect of the plant and vase, book, and mask seem to float on a two-dimensional table; the result makes the wall appear illusory.

OLD STONE

Producing an old stone effect, whether it be on floors, walls, cabinet tops, mantles, or corbels, is an easy and basic technique to achieve. It also looks good when applied to window and door frames. Stone is an effect that works better in more traditional or country settings than in modern ones, but it can look stunning in any setting if used imaginatively. Not only is it inexpensive, but it can be a very enjoyable project. While it is usually better to stay with the traditional tones of gray, other colors can also be used.

In reality, real stone contains flaws and cracks, and therefore any mistakes that you make can easily be utilized as part of the finished result.

If you want to create a realistic finish, study a real piece of stone. Note the structure and patterns on the surface after years of exposure to the elements. The most effective and realistic result can usually be attributed to a good eye for detail.

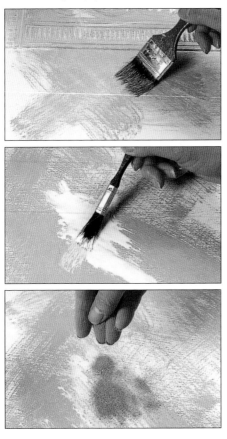

1 Fill and sand only the worst areas. Apply a base coat of pale cream latex. Let dry. Then, apply layers of pale gray and mid-gray emulsion using random strokes in a scratchy, crisscross pattern to blend with the base coat. Dry overnight.

2 Choose areas of the surface that would be particularly affected by the weather if in a natural situation and apply a generous layer of PVA glue with a 1/2 in. (1.3 cm) bristle brush. Spread the glue randomly across the surface.

3 Apply silver sand to the wet surface, spreading it as evenly as possible and making sure that all the glue is covered. You can add sawdust or fine grit to give an even more pitted texture. Allow to dry.

4 In separate clean containers, mix glazes of moss green, white, and dark gray (black and white) using artists' acrylic paints and acrylic glazing medium, following the manufacturer's instructions. With water, dilute the glazes to the consistency of light cream.

Apply a layer of dark gray glaze using the bristle brush. Make sure it covers all the sand. Allow to dry until tacky.

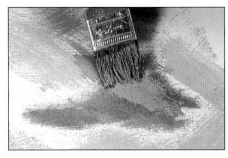

5 Apply the moss green glaze evenly, using the bristle brush.

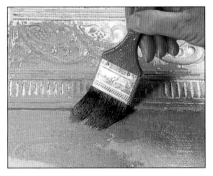

6 While the moss green glaze is still wet, randomly wipe and rub the surface with a lint-free kitchen cloth to remove part of the glaze. Highlight raised areas by exposing the gray underneath but keep the "moss" in tact in all the textured areas.

7 Mix the remaining white glaze with more water so that it is diluted to a very thin consistency. Diluted white latex could also be used. With a fine artists' watercolor brush, dribble the glaze down the surface to create the effect of salt on old stone.

8 Old stone can give very individual effects. Here, a traditional look has been created using "carving," accentuated by the use of colors of old, gray stone and damp moss. Finishing off with a matte varnish adds to the reality of a weather beaten pitted surface.

145

SANDSTONE

Sandstone is a warm, textured stone reminiscent of Ancient Egypt, the Mediterranean, and fairy tale castles. This technique will enable you to create a sandstone effect in your home with relative ease. The key to success with this technique is the preparation, and maximum effect can be achieved in a minimum of time. Unevenness of the surface will enhance the texture of the final effect.

FAUX STONE BLOCKS

Prepare your wall in the same way as for any other effect, but add an unthinned coat of PVA adhesive and allow it to dry. A simple stone-block effect can be produced by marking out the selected wall area with a plumb-line and spirit-level, and sponging and spattering the surface, which is then divided into blocks by painted lines. This is an effective way of achieving a sober, elegant look.

I Thin a raw sienna wash with water and apply it liberally with a brush. Work small sections at a time, as the plaster is very porous and will soak up the wash rapidly.

2 Rub on water-thinned white latex, covering the area which has been treated with sienna.

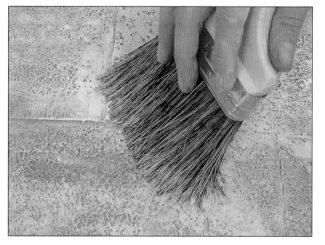

4 Rub each block with a rag so that in some areas the sienna color fills the depressions and in others it covers the white. Continue coloring sections with the sienna and white application and rubbing it with the rag until the entire area is treated.

5 Paint in pale gray mortar lines with a sword brush.

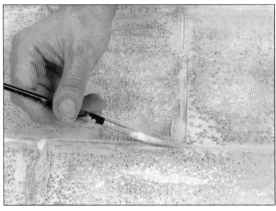

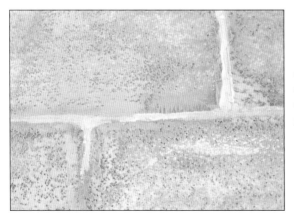

6 When the surface is dry, protect it with a water-based sealer such as PVA.

PORPHYRY

Porphyry is a very hard variegated igneous rock with a granite-like texture, often containing fool's gold. Although it occurs in different colors such as green and reddish-brown, it is most commonly found in its predominantly purple form, and its name means "purple stone." This effect is best used on plinths and columns. The technique involves two basic finishes – the ground coat, which is sponged off, and the glaze or top coat, which is spattered.

1 Apply the color-mixed glaze to the surface with a brush.

2 Using a clean, dry, synthetic sponge, even the glaze and remove the brush marks. Pounce the sponge over the area.

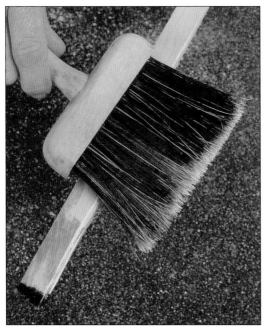

4 The combination of the fine, drawn-up pinnacles of stipple and the white spots of spatter can be an attractive finish in its own right.

3 Load a spattering brush of your choice with white, oil-based undercoat thinned with white spirit to the consistency of milk. Tap the brush against the spatter stick, releasing speckles of paint onto the ground.

5 The addition of a gold spatter to imitate the fool's gold often found in porphyry complements the effect.

6 The finished effect imitates the rich color of the real stone to perfection.

PEWTER

*A*ntique candlesticks, serving platters, and tankards full of mead
and wine come to mind when you think of pewter. This is a
very easy effect to create with silver and black paints, using the simple
techniques of antiquing, ageing, and distressing. Pewter, because of its
own natural qualities, works well in both period and modern settings,
creating a bridge between the old and the new.

A well-executed finish on doors and cupboard units will create a
conversation piece in any setting, although this effect need not be
confined to these areas alone. Smaller items such as boxes, tables,
lamps, and even architectural fittings can all be embellished. For very
little expense and with only the minimum of experience, you can
create the richness of real metal.

Preparation is a crucial part of a quality finish, although your
specific preparation will depend on the final effect you're looking for.
For an old, battered, antique look, for example, small defects in the
surface may be left, or even created, using a hammer, nails, or a set
of keys. If a smooth finish is required, proper sanding and sealing
should be carried out.

CREATING THE PEWTER EFFECT

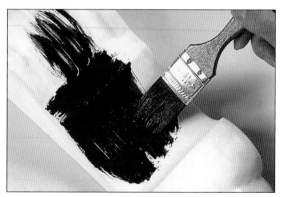

ABOVE: This technique
adds brilliance to carved
and molded surfaces,
such as this corbel, as
easily as it does to
panelled doors or simple
candlesticks. Striking and
individual, it can be used
to embellish any scheme.

1 Seal the raw plaster surface with neutral diluted
latex. Let dry. Apply two coats of black latex using a
2 in. (5 cm) bristle base-coat brush. Let dry.

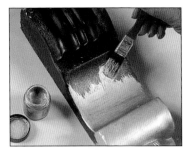

2 Apply the silver metallic acrylic paint using a 1 in. (2.5 cm) bristle brush, without too many brush strokes. Dry. As an alternative to silver acrylic paint, you can use spray paint available from most hardware stores and follow the manufacturer's instructions.

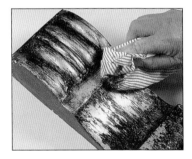

3 Mix some black artists' acrylic paint with a little water to make a creamy consistency. Apply a generous layer over the surface using a bristle brush. You may prefer to use black latex, which will work just as well and is often less expensive.

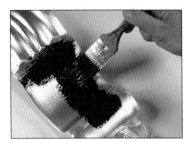

4 While the paint is still wet or slightly tacky, remove any excess from the surface with a damp, lint-free cloth or a kitchen towel. For an older and more worn look, rub the black paint into the silver base coat. For a slightly tarnished look, expose less of the silver base coat. Leave to dry.

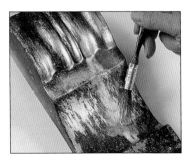

5 Seal the surface with two coats of matte acrylic varnish using a varnishing brush.

GRANITE

Granite is a stone of solid texture and appearance that can be produced in varying colors. It is used in large spaces for buildings and floors. Granite is particularly striking when used in conjunction with other stone or marbled effects. Granite is best used in areas where it will seem most natural, such as carved fireplace mantles, floors, and smaller decorative items such as statues, corbels, and tabletops. It is a reasonably easy effect to achieve once you have mastered the techniques of sponging and spattering, and it works very well in both modern and traditional settings. Used in a wide range of different colors, the granite effect can add interest to an otherwise very simple setting. The cost of a natural sponge and oil-based paints and glazes can make this technique a little expensive, but the finished result should prove worthwhile.

RIGHT: A very quick way to alter the final effect is simply to change the color of the base coat. Here, a pale pink has been used instead of the traditional gray, sponged over with a layer of pale gray followed by mid-gray, and finally a little black. By masking and lining the edges, a credible inlaid effect has been achieved.

GRANITE EFFECT ON A PINE FIRE SURROUND

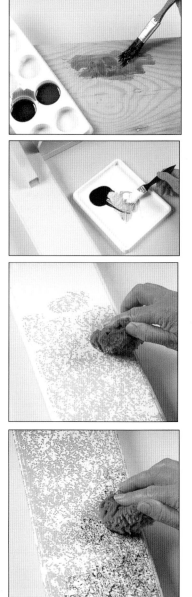

1 Knots in wood produce a resin which can cause discoloration through paint. After sanding and filling your surface, seal any knots with a little shellac solution which can be applied with either a brush or a soft cloth. Allow to dry. Apply an oil-based undercoat and allow to dry. Apply two coats of the pale gray eggshell base coat and allow 24 hours to dry.

2 Mix up a mid-gray from equal quantities of black and white oil paints. Dilute with a little white spirit to make a workable (but not too thin) consistency.

3 Dampen a natural sponge with a little white spirit and dip the sponge into the mid-gray paint. Dab on some clean paper towel or clean paper to remove any excess. Carefully and randomly sponge over the surface.

4 Dilute some black oil paint with white spirit to a working consistency and repeat Step 3. For corners, use a small piece of sponge attached to the end of a pencil. Repeat the process with white oil paint.

5 Apply at least two coats of oil-based gloss varnish, allowing adequate drying time between coats.

MALACHITE

Malachite is a rich green mineral formed of copper carbonate, so named because of its color that resembles mallow leaves. It is noted for its circular "bull's-eye" veining. Found predominantly in Eastern Europe, malachite has been used to great effect in Russian architecture, but is most often seen elsewhere as jewelry or a decorative addition to furniture. Like all natural substances, malachite occurs in differing shades ranging from aqua green to emerald, and the bands of color which overlap to make its characteristic bull's-eyes vary from one stone to another. This effect has often been simulated in the past by using brushes and combs. The technique shown employs only brushes, in order to achieve a more muted result.

CREATING THE MALACHITE EFFECT

1 Apply the viridian glaze in a haphazard way, manipulating the brush to move the color all over the surface.

2 Using the artist's round brush, start to make swirling marks. Hold the brush at the very tip, and roll it between your finger and thumb to change direction. In this way, tight maneuvers can be made quite easily. This is a good time to play with the glaze and experiment with different shapes. There is no time pressure – the glaze will take a while to begin tacking off. If it does, you can remove and reapply it.

3 The monestial green glaze now comes into play, applied in a similar way to the viridian. At this point, a vague scheme should be evolving. The monestial glaze should cover about 80% of the area, leaving the viridian to glow in shallows and highlight the figuring.

4 Create bull's-eyes of different sizes by twisting the brush between your finger and thumb. Do not rush – a quick movement tends to introduce straight lines, which can be disastrous to finish.

5 The circular tracks, like mysterious contours on an undersea map, should meander around and under the bull's-eyes and each other.

6 The blue-black will help accentuate the impression of changing depths, and white spirit splattered on with a stencil brush will give a less-contrived feel to the effect.

7 Using a stencil brush loaded with white spirit, retrace some of the lines made previously. The glaze will dissolve and show the ground color through a veil of green. Introduce some blue-black glaze to the pattern, especially in the bull's-eyes.

8 The completed effect shows the degree of depth which can be achieved with this finish.

SLATE

As with any simulation of stone or marble, slate is best used in situations where it might appear naturally, such as fireplaces, counters and tabletops, and small boxes. When used in larger areas such as floors, it is best used with a marble finish to create a paneled effect. Reminiscent of country kitchen floors

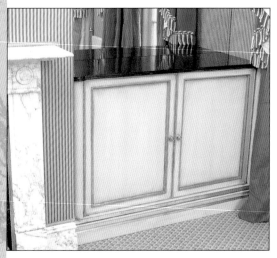

or paving stones, the slate technique is fairly easy to perfect – requiring only a little practice with glaze manipulation and frottage.

Slate, when used to highlight an architectural feature, provides great depth and definition due to its stratified color. The finished effect of this special technique can make a plain surface both interesting and highly unique, as in the alcove cupboard shown here. It has been treated with a pale antiquing effect, given definition by the gilded moldings, and topped with a highly-polished faux slate effect which picks up the dark marble of the fireplace. Follow the step-by-step instructions below to achieve a realistic slate effect.

I Fill any holes or cracks with a store-bought filler, using a spatula or knife blade. Allow to dry overnight. Sand to a smooth finish using medium- and then fine-grade sandpaper or a sanding block. Remove all traces of filler and dust with a soft brush and a damp cloth. Apply an undercoat and allow to dry.

2 Load the bristle basecoat brush with mid-gray eggshell paint. Do not overload the brush – the paint should come about two-thirds of the way up the brush. Apply two layers of base coat, allowing the paint to dry between coats.

3 Mix up a glaze, following the manufacturer's instructions, from transparent oil glaze and black oil paint. Dilute with a little white spirit to half-and-half consistency. Make sure that the glaze and paint are completely blended. Apply a layer of glaze, working on a small area at a time and keeping a wet edge. Stipple out the brush strokes.

4 Lay a sheet of newspaper over the surface and roughly smooth it down. The final effect will be enhanced by any folds or creases, so they don't need to be removed. Overlap the areas slightly to avoid any broken lines.

5 Remove the newspaper and discard it immediately, making sure wet paint or glaze does not mark other furniture or areas. Immediately apply a fresh glaze to the next area and repeat Steps 4 and 5. Allow the entire surface to dry. Seal the surface with a varnish.

6 The finish of highly polished stone, whether it be granite, marble, or slate, adds a feeling of luxury to any decor.

PAINTED IRON

*T*he finish of metal, whether it looks brand new or like it has had many years' exposure to the elements, can create an excellent effect around your home. It can be employed to create a myriad of effects, each of a unique nature. A metal paint finish can give the impression of increasing the size of a room, or it can reflect available light in a very mellow or theatrical way.

The look of painted iron can be used to great effect on doors, paneling, and baseboards, as well as fireplaces, frames, and decorative items. The painted iron look is inexpensive to achieve, and with a little practice and an eye for detail, plain surfaces can become focal points in any setting. Just follow the step-by-step guide given here to achieve good results.

1 With a bunch of keys, a screwdriver, or any metallic object, score and mark the surface at random. Be careful not to overdo this, as too much can spoil the final effect.

2 On areas where natural oxidation would occur, evenly apply a generous layer of PVA glue using a bristle brush. Sprinkle sand over the surface of the wet glue. Let dry and dust off any loose sand.

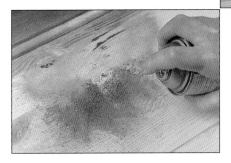

3 Spray the surface with two or three thin coats of silver metallic spray paint following the manufacturer's instructions. Allow to dry between coats. To vary the color of the silver, use silver acrylic paint or chrome spray in addition to the silver metallic spray. Allow to dry.

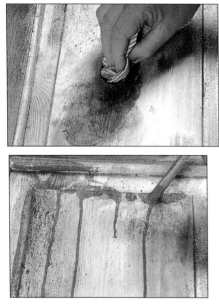

4 In a clean dish, mix a little black artists' acrylic paint with raw umber. Add water to get a pouring consistency. With a soft, lint-free cloth, apply the paint to the metallic surface. Work it into the grain to form a tarnished effect, but leave some untarnished areas.

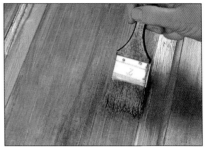

5 Dilute a little rust-colored latex or acrylic paint with water to achieve a light, creamy consistency. With a Fitch brush, dribble it down the surface in natural rust areas. Just before the dribbles dry, carefully wipe them with a soft cloth to remove any still-wet paint, but leave a textured sharp edge.

6 Apply a layer of sealant or varnish if required, following the manufacturer's instructions. Use a satin varnish to achieve a slightly polished metallic finish.

7 The painted iron effect on this door creates a positive and forthright effect. The use of silver accentuates the moldings reflecting movement and yet, at the same time, retains a sense of solidness. This is a technique that makes a very strong design statement.

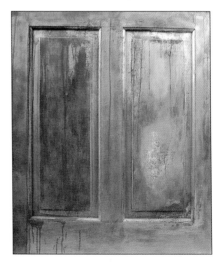

MARQUETRY

Creating the beautiful and exquisite patterns of marquetry, or simply using paint to emulate the effect, can result in many outstanding and unique projects. Once completed, years of satisfaction and pleasure will be guaranteed. Inlaid patterns in wood can enhance any decor. Marquetry can be applied to floors, fireplaces, fitted units and doors, and many smaller items such as tables and boxes. Although marquetry is very inexpensive to create, patience and practice are necessary in order to create a high-quality finish.

A well-prepared, smooth surface free of flaws and holes is vital for achieving good results. Old paint and varnish must be removed completely – otherwise, the paints will not be able to penetrate the wood to reveal the grain.

EBONY INLAY ON WOOD PANELING

LEFT: This panel has been given the look of an ebony inlay using black and white. It is best to keep to simple patterns and designs, and true inlay may be simulated by using plain, flat colors. Other finishes that can be achieved include tortoiseshell and mother-of-pearl.

1 Fill all holes with a store-bought filler following the manufacturer's instructions. Sand away all excess. Remove all dust. Seal all knots with shellac and allow to dry. Using a bristle basecoat brush, apply an undercoat. Allow to dry. Apply two top coats of pale cream eggshell. Allow the paint the dry completely between coats and before commencing the next step.

2 Enlarge or reduce the image to the required size. With a pencil or ballpoint pen, trace the design onto the door panel. Make sure the outline is complete before removing the image.

3 In separate dishes, pour equal proportions of acrylic in black and dark gray. Add water until the paint achieves a consistency of pouring cream or a thickness that you find easy to paint with. With a water-color brush, carefully paint in all the relevant sections of your design in the dark gray acrylic. Allow to dry. Repeat with the black paint using a clean brush.

4 Measure and mark a suitable border with chalk. Apply a line of low-tack tape along the inside edge. Leave a ¹/₄ in. (0.63 cm) gap and repeat with a parallel line of tape. Press both layers of tape into position to avoid seepage.

5 With a ¹/₂ in. (1.3 cm) bristle brush, paint between the parallel lines of tape with the black paint. Do not use too much paint, as this will cause seepage. Allow the paint to dry before very carefully removing the tape.

6 With a single straight-edge and a medium gold permanent marker, outline both edges of your black line. Move the marker along the straight-edge quickly and evenly to avoid too much gold ink running onto the decorated surface. Use the straight edge to balance your hand if lining an awkward recess. Spray with sealant before continuing.

COLORED PHOTOCOPIES

*D*ecorating a whole room with colored photocopies or simply placing one or two in strategic positions can be magnificent. It can produce some unique results, particularly if the subject matter has a special meaning to you and your family. The possibilities are endless, and the final results are always well worth the effort.

For the inexperienced artist, photocopies can be a very simple way to create whole scenes and cover large areas, or just to add a splash of decoration in a chosen space. Photocopiers can enlarge or reduce images, enabling their use on items ranging from cupboard doors to entire walls. The use of photocopies lends itself to any decorative scheme, and it is very inexpensive and comparatively simple to master.

1 Measure the area to be covered and have the chosen images either reduced or enlarged to the required size. Always have extra copies made in case of mistakes.

2 Color in the photocopies as required. If you are using watercolor or acrylic paints, apply photocopier-size liquid first to strengthen the paper. Keep the paint as dry as possible to minimize any chance of bleeding. Allow the paint to dry before progressing.

3 When you have completed the coloring, spray the image with at least two (thin but thorough) coats of sealant.

4 With sharp scissors, cut out the image required – fairly evenly but not precisely. With a pair of fine pointed scissors or a craft knife and cutting mat, slowly cut around the picture to the required shape. Be careful not to cut through a section that is to be used.

5 Arrange all the pieces of the image into position. Then, with a bristle brush, apply a coat of PVA glue or high-quality wallpaper paste to the reverse side of the image. Always make sure that the glue is applied evenly.

6 Position the image on the surface. With a damp, soft cloth or sponge, carefully remove all air bubbles and any excess paste.

7 The use of colored photocopies on the wall, as shown on the right, has created a print room effect for very little expense. The availability and range of material is endless, and the use of color will add excitement and interest to any wall or setting.

DÉCOUPAGE

Découpage, or the art of applying paper cut-outs to a surface, is an extremely popular decorative technique that can transform everyday objects into works of art. Finding ideas for découpage from magazines, calendars, and other sources can be as much fun as applying the technique itself! An attractive découpage can be created with a minimum of skill. The art of this effect lies not so much in the selection, cutting out and sticking of the designs, but in the way they are arranged on the surface and the choice and application of the finishing varnish. Map out your design on a sheet of paper the same size as the surface you wish to cover, and don't begin gluing until you are completely happy with the composition.

DECORATED CHOPPING BOARD

BELOW: This rustic-looking decorated chopping board would enhance any kitchen, either modern or traditional.

1 Sand the chopping board and wipe away the residue with a tack cloth. Make a wash of color by mixing a little of the medium green paint with water until it is of an inky consistency. Brush this mixture over one side of the board.

2 From a magazine, wallpaper, etc., cut out colored pictures which complement your decor. Carefully trim away the excess paper. Arrange the cutouts on the board in a nice pattern. With a 1 in. (2.5 cm) brush, apply an even coat of craft glue to the back of one picture, and use your fingers to press it into place. Glue each picture in the same manner, then gently rub across them several times in different directions to remove any air bubbles. Set aside to dry.

3 Using a 2 in. (5 cm) brush and vertical strokes, apply an even coat of glue over the top of the board and let this dry. Then, repeat with horizontal strokes and let dry. Brush on a thin, even coat of crackle medium and allow it to dry until it is very tacky, and then brush a coat of satin varnish over the medium. Cracks will form during the drying time.

4 Rub the light brown gel stain into the cracks with a paper towel or soft cloth, and wipe away any excess. Allow this to dry thoroughly, and then spray or brush on a coat of satin varnish. If desired, a ribbon can be added for decoration.

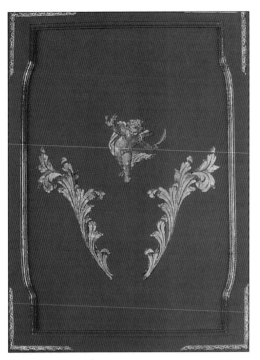

DÉCOUPAGE ON A DOOR PANEL

The enormous amount of source material available means that découpage can vary from the simple and casual to the exotic and opulent. The door shown here, in rich burgundy and gold with cherubs and acanthus leaves antiqued to remove the new crispness, creates a feeling of real romanticism. Make sure the surface is properly prepared, as all flaws will show. Cut out and position the various elements of the design carefully to ensure the result you want. If mistakes do occur, remove the picture and replace it with care.

1 Prepare the surface. Apply a white or pink oil-based undercoat and allow to dry overnight. Apply two coats of burgundy eggshell using the laying off technique.

2 Spray your selected photocopies with a coat of sealant, following the manufacturer's instructions. This will strengthen the print, allowing for easier cutting and gluing later on.

3 Allow to dry for a few minutes and then roughly cut around the image. Using fine scissors or a craft knife, carefully cut out the details.

4 Experiment with different arrangements of the images until you achieve what you want. Do this on a sample area or on the cupboard panel carefully using a little blu-tack to fix the image in place. Do not press too hard, as this will crease the image.

5 When you have finalized the arrangement, apply some PVA adhesive or good-quality wallpaper paste to the back side of each cut-out, and put some paste on the door panel. Slowly position the cut-out onto the surface and remove all air bubbles by wiping a damp cloth over the cut-out and smoothing towards the edge. Wipe away any excess glue.

6 When dry, apply at least 3 to 4 coats of a suitable varnish. Here, we have chosen an oil-based gloss varnish tinted with just a hint of yellow ocher in the first coat only. Allow to dry between coats.

PAINTING TILES

The diversity of paint is limitless. An expanse of plain tiles presents an excellent face for decoration, and today there is a wide choice of tools designed specifically for tile effects, although it is worth considering making your own. Paint can be applied using more or less anything – a crumpled plastic bag, a sponge, an old toothbrush, feathers or fabric, to name a few. It's a good idea to experiment with different techniques on a few tiles and simply remove the paint before it dries. Since glazed tiles are not absorbent, more durable paints such as enamel or acrylic are suitable. Make a sample board and test each color before applying it to a tile. Experiment and take into account the effect of light in the room, which can create mood changes and completely alter the intended feel.

CHECKERBOARD COLOR WASH

This checkerboard color wash design will add a fresh dimension to your kitchen or bathroom. Enamel paints are available in a wide choice of bright colors which, with their reflective quality, can create a feeling of playful modernity.

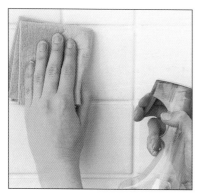

I Clean and prepare the tiles to be painted. Be sure to remove any dust particles and grease marks.

2 Cover tiles to remain white at random with masking tape. Those chosen can be changed as you proceed, but an initial indication is helpful. Place a strip of cardboard against the bottom edge of the tile you wish to paint, completely covering the grout. Using a sponge, dab paint along the cardboard edge. Placing it in the same way, move around the tile edges, working the paint towards the center.

3 Repeat this process for other colors, using a different piece of cardboard so that colors are not transferred to other tiles. Do not worry about smudging; this can be cleaned up later. Try to keep the work area free from dust and let it dry overnight.

4 Clean the grout, removing any excess enamel with a cotton swab dipped in white spirit. Do <u>not</u> let it run, as this will leave a streak mark on the tile. Stained grout can be touched up with white acrylic paint. Where it persists, press in a little fresh grout and remove any excess with a damp sponge.

ART DECO TILE DECORATION

The Art Deco movement of the 1920s and 1930s was greatly influenced by Cubist art and the Industrial Revolution. The style is characterized by strong geometric lines, creating a confident and classical look. Inspiration for motifs such as the one illustrated here can be found in the publications of the period.

1 Measure a tile and draw it to scale on a piece of paper. Draw a line down the middle of the square, then divide each side in half again. Measure across to make 16 equal smaller squares.

2 Use a ruler and pen to draw your design. Start at the middle vertical line and work outward, using the ruled lines as a grid to achieve symmetry.

3 Experiment with color and try different combinations. If the design is to be used as a border, check that the image works as a repeating pattern. Keep the design as simple as possible; sometimes less detail can mean more impact. Use a black fine-point permanent ink pen to define the design accurately.

4 Place tracing paper over the design and hold it in place with masking tape. Trace the corner edges of the tile and then the design itself. Take time to do this accurately – any mistakes will be carried through to your finished tiles.

5 Cut a piece of transfer paper slightly smaller than the tile and tape it to the tile, graphite side down. Position the tracing on top by lining up the corners, and tape it in place. Using a ruler and a ballpoint pen, trace firmly and accurately over the *entire* design.

6 Remove the transfer and tracing papers. Retrace the design on the tile using a fine-point permanent ink pen. Use strips of cardboard to mark any lines — it is more absorbent than a metal or plastic ruler, and therefore has less tendency to smudge. Wait a moment before

lifting the cardboard directly away from the tile; do not pull it away to the side, as this will smudge the line.

7 Fill in block areas of color, working as closely to the outline as possible, and then draw a neat black edge. Use a craft knife to scrape away mistakes. Repeat this process along the tiled wall. Remove smudges, fingerprints, and dust, using a cotton swab soaked in lighter fluid.

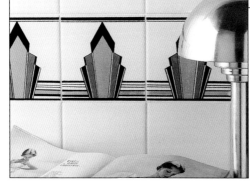

8 The finished effect.

ENAMELING

Many people still think of enameling as a professionals-only craft. But now that very compact and inexpensive kilns are widely available, the craft is becoming more and more popular among amateurs. One of the joys of enameling is that the fundamental techniques are relatively easy. In fact, once you have mastered the first stages, you will be able to produce beautiful jewelry, bowls, and tiles that glow with durable color.

Enamels are available in three different types – transparent, opaque, and opalescent. Transparent enamels allow light to pass through them and reflect the surface beneath. The brighter the surface of the metal before enameling, therefore, the brighter the enamel will appear. The density or tone of a color deepens with successive applications.

Opaque enamels completely cover a metal surface so no light is able to pass through it. After firing, they have a shiny appearance.

Opalescent enamels give a slightly milky appearance, which allows some light to be reflected from the surface of the metal. They require very accurate firing to achieve their pearl-like appearances.

You can buy these three types of enamel in lump, frit form, or powdered.

Lump or frit enamels look like small lumps of colored or clear glass. Lump enamel is stored in airtight containers to prevent deterioration, and it should be completely dry before storage. When it is stored correctly, lump enamel will last for several years.

Before it can be used, however, you will need to grind the lumps with a mortar and pestle.

Powdered enamels have been commercially ground and packed. They do not usually need any further grinding, but they should be washed before use. They should be stored in a dry place and in an airtight container, but even then, they deteriorate more rapidly than lump enamel. I would recommend you use powdered enamels to start with – they are quicker to use and you will soon become familiar with the feeling of them when you grind and wash them.

Enamels should look a little like fine salt before they are laid on the metal for firing. Both powdered and lump enamels contain some impurities, and they must be washed before use.

Lump enamels

HOUSE NUMBER TILE

A stencil was used to enamel this house number tile, which is decorated with painting enamels. Use a hard white for the enamel background. To get a really good finish on your tile, rub down the white enamel with diamond abrasive, a carborundum stone, and grade 240 wet and dry papers until you have a perfectly smooth coat. Refire the tiles to return them to a gloss finish.

I Sketch out the number of your house, or find some suitable numbers for your tile that you can copy. Trace the design and transfer it to paper to make a stencil.

2 Work on a cutting mat or something similar, and use a craft knife or scalpel to cut out the numbers to form the stencil. Find and mark the horizontal and vertical center lines on the stencil.

3 Make sure that your tile is clean by rubbing it lightly all over with wet and dry papers. It is easier to mark your pattern on a slightly matte surface.

4 Lightly mark the center lines on your tile in pencil, and sketch in the position of the border pattern.

HOUSE NUMBER TILE (continued)

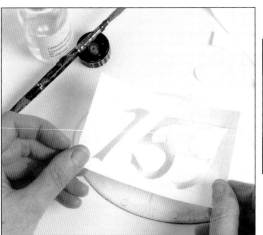

6 Sift blue enamel through the stencil and onto the tile.

5 Apply a coat of gum to the area where the number will be on the tile, and hold the stencil over the tile or rest it lightly on it.

7 Carefully remove the stencil.

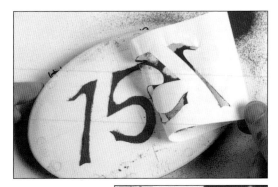

8 Touch up the enamel around the numbers, and brush away any excess enamel with a moist paintbrush. Place the tile on a large support, and lift it carefully into the kiln. The area of enamel at the back of the kiln will fire before the area at the front, so you should turn the tile around so that it fires evenly. To do this, prop the door open, lift the tile out onto the support, place it down on the tile immediately in front of the kiln, and pick it up the other way around with a firing fork, replacing it in the kiln for further firing.

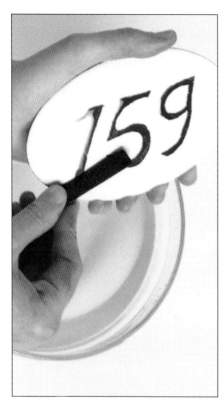

9 When the blue enamel is smooth, remove the tile from the kiln and allow it to cool. Rub down any unevenness of the numbers, using a carborundum stone under running water.

10 Put small heaps of the painting powders for the decoration at either end of a glass tile. Use a spatula to put a drop or two of lavender oil next to the painting enamels. Then, gradually pull the oil into the powder, pressing down hard on the tile to mix it in well. The mixture should be a soft, creamy consistency for painting. Do not make it too thin, or it will disappear in the firing; or too thick, because then the finish will be dull.

11 Use a fine paintbrush to paint the border decoration, one color at a time. Leave to dry on top of the kiln for about an hour. Before firing, check that the paint is dry by placing the tile at the mouth of the kiln to see if evaporation takes place.

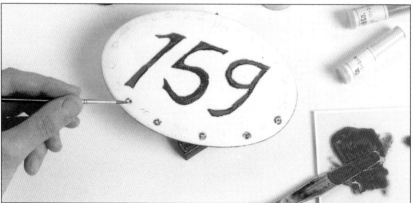

12 Fire until the painted enamels take on a glossy appearance. Turn the tile around if necessary, and then remove and cool slowly in front of the kiln.

Floors

Treating a floor with paint effects can transform the appearance of a room. Many effects are suitable, from combing and marbling to stenciling and *trompe l'oeil*, depending on the setting and the desired mood. When choosing your effect, consider the area as a whole and visualize the overall pattern of your design in relation to the shape of the room and the furniture it will contain.

As with most design jobs, planning and preparation are the keys to success. The floor must be in good condition before any paint is applied. If you are working on floorboards, mend all loose and damaged boards, fixing them securely with nails or screws. Next, ensure a smooth and even surface by sanding the entire floor with a belt sander. These tools can be rented from most hardware or home stores. Avoid sealing off the racks between each board, as these allow movement and air circulation, and stopping them could cause dampness.

PAINTING FLOORS

*F*loorboards look best simply combed in one color, in the direction of the grain. This still leaves you plenty of decorative scope, as color possibilities can range from light and pretty (like mid-gray dragged over white) to dark and dramatic (like black over red). Hardboard and chipboard panels can take some very jazzy treatments and the range of designs is astounding – from simple, straight-line geometrics to complex curves – that a simple tool like a comb can produce. One way to think of such a project is as if you were creating your own, large- or small-scaled, tiled floor, and, with this in mind, carry out the combing accordingly.

Stick to flat-oil paint, undercoat or eggshell for floors. Prime new wood, then undercoat the floor and apply at least two coats of undiluted, or only very slightly thinned, paint to provide a good, solid ground. Whatever type of floor you're painting, don't forget to paint yourself out of, not into, the room! With floorboards, start in the opposite corner from the doorway and follow the principles for one-way dragging, painting and combing a couple of boards at a time. The advantage of laying a new hardboard/ chipboard floor is being able to paint and comb the panels before you lay them. If the panels are already down, the easiest way to keep edges neat is to do them in a checkerboard sequence (as if you were working first on all the white squares on a chessboard, then on the black), masking the edges each time and waiting until the first set is dry before masking, painting, and combing the second. Either way, plan the floor out on paper first, so you know exactly what you're doing, and use chalk lines to snap the position of panel edges onto the floor if they won't correspond exactly with the panels as laid. It may be, for example, that the chipboard is laid in rectangles where square panels are wanted. Once the combing coat is dry, protect the finish with polyurethane varnish – two coats will give you a certain degree of protection, but three coats will give real durability against the inevitable wear and tear that any floor will receive. It is always worth taking the trouble to apply these extra coats.

LEFT: Both the color and texture of this red brick floor make it hard to believe that this result was really created by paint. It has the look of genuine age about it. Lining has been applied so effectively that it has the appearance of beautifully-laid bricks.

RIGHT: This magnificent floor would require artistic ability to emulate. The peacock design was painted in oils onto stripped floorboards, sealed with matte varnish, and polished with beeswax.

BELOW: A daring and imaginative treatment of a woodstrip floor. It is almost entirely combed in biscuit over cream, but the original floor shows through in a diamond relief pattern, contained by a straight-dragged and wavily combed green border that resembles a rug.

MARBLING FLOORS

Below is a fine example of a wooden floor, painted in the form of marble tiles and varnished.

FAR RIGHT: A quartered effect, with differently colored frames of marble makes a wonderful floor covering. The painted cracks running from the skirtings lend an air of antiquity to the classic design. Beneath the effect lies parquet flooring, which is an ideal surface for painting because the tightly fitting blocks can be sanded and filled to a smooth unbroken surface.

Wall paints, artists' oil colors and specialized floor paints are all suitable for floor marbling. In the case of the first two, the prime difference lies in the number of coats of protective varnish necessary – about five. If you are going to apply a very fine, delicate marble effect, well protected by a varnish, such a delicate finish is going to look very odd on floorboards where the planks are more than $^1/_{16}$ in. (1.5 mm) apart. You are never going to come across marble arranged in long, boardlike slabs side by side, not to mention veins that mysteriously jump over the cracks to the next block. Either you must fill the gaps between the board, or you must apply a much bolder, freer pattern to the marble, so that it is obviously a marble effect – in the same way that a book cover may be marbled – rather than an attempt at direct simulation of the real thing. Similarly, you should be careful when choosing your coloring. A bathroom or kitchen floor given a marble pattern with a white ground and blood-red veins will conjure up all sorts of gory images. On hardboard or chipboard floors, or on floorboards with the spaces well filled and sanded, the methods used for walls and other woodwork can be followed. On a floor, it is wise to use three coats of gloss or semi-gloss varnish topped by two coats of matte; this gives a sheen and a sense of depth to the color and evokes the natural properties of marble surfaces. The darker marble finishes, such as red or serpentine, look well on floors because of their visual weight.

FLOOR PAINTS Specialized floor paint is an effective marbling medium. Even its limited range of coloring is no drawback, as the colors can be inter-mixed and the muted tones are more of a help than a hindrance. There are two ways of mixing. Firstly, the base color can be applied at full strength and the veins, thinned to a 1:3 ratio of mineral water to paint, applied with a brush, or two or three feathers tied together (to cope with the thicker quality of the paint). The base color is then applied again in the spaces between the veins, and the two wet edges blended and softened together with a feather or dry brush. The alternative technique is to apply the base color and the veins simultaneously, using one brush for each color, and then blending the two together with a feather or dried brush.

Try to visualize the overall effect of the floor on the rest of the room. Remember any rugs and where they are going to be placed so that they do not cover up your design. Many of the techniques described in this book can be applied to floors, but first the floorboards must be repaired, filled, secured and finally sanded, and all dust removed.

Walls

What you do with the walls sets the stage for the look and feel of your rooms. In interior design today, "textures" are hot. You can't pick up a home-design magazine that doesn't show rooms mixing and matching them with ease. "Textured" wall finishes offer simple and affordable ways to introduce the look into your interiors. The finishes are great complements to some of the newest decorating styles.

Choose the color of your walls with care. They are the largest area of a room and their color will be the key to your décor. Remember that a color will seem stronger when it is on the walls because of its increased area. Dark colors will reduce the size of a room and pale colors will add light. Consider which way the room faces, and check the color circle for shades that will lend warmth or coolness.

Because the wall is a large expanse, even the quickest finish will take some time, and the decoration of walls calls for a methodical approach. Preparation is by far the most important part of the process. If the surface is not smooth and clean, even a specialist would have problems, and no amount of later care will make up for skimming in the early stages.

PREPARING A WALL

The type of effect required will determine the exact preparation necessary to a wall, but whatever you decide, old wallpaper should be removed completely and any cracks filled with a filler and, when dry, sanded to a smooth finish. An undercoat or primer should be applied to seal the surface before base coating. Paint quick drying shellac (or knotting solution) over any newly filled cracks to avoid color imperfection when applying the base coat. If the walls are very damaged, apply lining paper before priming and base coating.

Certain techniques that require an extremely smooth surface, such as lacquering and marbling, may mean that skimming is necessary after priming. This is done with skimming plaster (or spackle) and is extremely difficult to perfect. Using a skimming blade, pass the plaster across the surface, filling all indentations. Use even, smooth movements. Wipe the blade clean and pass again over the surface. Slightly dampen the blade if necessary. Depending on the size and condition of the wall, it may be better to call in a professional plastering and decorating firm to do this for you.

COLORWASHING AND GLAZING

The main target in ageing a wall surface is to soften it, not darken the color. Walls that aren't flat and can't be made so – like many in older buildings – benefit from a matte color wash. A very thin wash should be used on them. The paler blues soften with a thin, raw umber wash. A gray wall can be warmed by raw or burnt umber either separately or together, touched with a spot of black. Green surfaces need a slightly deeper green that can be cooled down with raw umber or warmed up with burnt umber. White walls need a very thin wash of burnt umber, and the same goes for off-white, beiges, dusty pinks, and yellow.

For level wall surfaces, oil glazes work very well. Their translucence, tinted delicately with the oil colors listed above, gives a patina of diffused softness that cannot be achieved solely with a paint wash.

BELOW: The blue and yellow of a curtain fabric are picked up separately on the wall, in a color wash above the dado rail and a rich blue drag below.

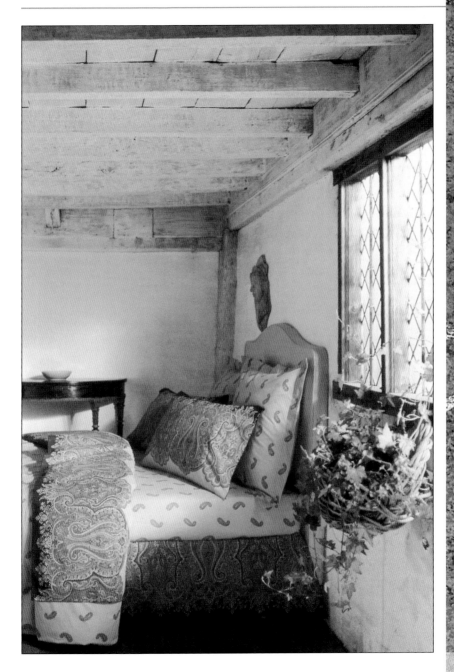

FEATHER-DUSTER FINISH

For a feather-duster look, you need only apply a little paint, hold your tool perpendicular to your surface, and use a light touch. But be sure to practice first on paper. Of course, every feather duster is different, so you won't get the exactly the same pattern as shown here. Be sure to choose your feather duster with care. As in many decorative painting techniques, you're printing with your tool, and the imprint you get can make or break your finish.

If the duster's feathers are too long, they might droop and give a blurrier effect. This is neither good nor bad — it just means you should test extensively to make sure you're happy with the impression you get. If the impression doesn't suit you, you might try trimming the feathers before you go out and buy another feather duster.

I Pour salmon glaze into a paint tray. Hold the feather duster perpendicular to the paint tray, and dip the bottom of the feathers into the glaze. Make several impressions on paper to test that you have the proper amount of paint. Then, working in 3-foot sections, touch the feather duster lightly to the wall, making imprints several inches apart until you cover the entire surface.

2 Re-dip the feather duster in the glaze, and make additional imprints in between those on the surface. Continue filling in with imprints until you have the overall pattern. Stand back from the surface, as needed, to see where you need to fill in.

3 The all-over patterned effect can make a lively substitute for wallpaper.

ASSORTED WALL TEXTURES

The next two pages show examples of walls that have been textured using effects already explained in this book – for example, stenciling, colorwashing, combing, and ragging and flogging.

ABOVE: This rich but subtle bathroom incorporates a variety of paint effects. The colorwashed walls have been painstakingly stenciled to imitate wallpaper; the ceiling has been eggshelled, colorwashed, and varnished; the plaster surrounds are highlighted in lacquered bronze powder; the wall below the dado is ragged and real marble has been matched with faux marble.

ABOVE: With the appropriate choice of colors and a classical design, stencilling can be used to create a period look. Making your own stencils enables you to echo the pattern on a cushion or a curtain border.

ABOVE: The beautiful textured detail of combing can be seen to great advantage here on the walls below the dado rail. The "glow" of the Mediterranean look is completed by rag-rolling the walls in a sea coral color and highlighting the look with a Greek key pattern stencil in a simple marbled texture.

LEFT: In this Santa Fe-style kitchen, ash woodwork is wet off by green walls that have been flogged with a rag in three differently colored glazes – a combination of ragging and flogging.

Furniture

Furniture lends itself particularly well to paint effects. Traditional designs can be shown to their best using marbling and graining techniques. More contemporary pieces benefit from the fresh use of color, which has never before been available in such a wide and exciting range. As a rule, ornate furniture profits from subtle treatment, and a simple design can often be enhanced by a bold finish. Color can modify the character and even the apparent dimensions of a piece. Just as dark clothes may have a slimming effect, so a dark color tends to reduce the thickness of the legs on a table or chair. Bright, sunny colors give a country-cottage look, and dark, rich shades convey an air of elegance and refinement.

Painted furniture demands a much higher quality of finish than that of walls, and it can be more intricate to work on. It helps to turn a table or chair upside down and treat the innermost surfaces first. Often it is advisable to allow one area to dry before continuing, and you may occasionally need to varnish areas that could be spoiled if left unprotected. All furniture should be safeguarded from wear and tear by two or three coats of varnish at least.

TABLES

The word table derives from the old French tablel meaning a tableau or painted scene. Ironically, tables today are seldom given an interesting paint finish. Instead, they are simply stained, varnished, or glossed. Decorative paint effects allow you to try something different – marbling, woodgraining, lapis lazuli, malachite, spattering, dragging, pickling, liming, trompe l'oeil – these are just some of the ways of turning an ordinary table into an exciting decorative accessory.

Obviously, tables differ dramatically in build and appearance – ranging from a robust kitchen table with scrubbed top and heavy legs to a delicate occasional table with such fine legs that the top seems to float. When considering the decoration of a table, ask yourself how it will be used, and spend some time considering its design. The finish should complement the piece of furniture, not fight it.

ABOVE: Multicolored sponging gives texture and weight to this modern coffee table. The stone effects suits the wrought iron design, and the choice of color prevents it from appearing too heavy.

RIGHT: The subtlety of a gray-over-white rag roll creates a balanced look for this Regency-style table.

ABOVE: This understated table, has been antiqued with a nice honey-colored craquelure.

LEFT: This oak table has been stripped and then limed. All areas to be painted were masked during the liming process. The table edges and central design were painted with oils.

LEATHER-LOOK TILT-TOP TABLE

You will find this beautiful table is not only a decorative accent but a useful item in your home. Here, it has been finished in dark satin, but another color would look just as nice.

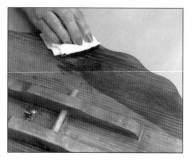

1 Lightly sand and wipe the entire table. With chalk or pencil draw a border 2 in. (5 cm) inside the edge of the table top, using the outer edge as a guide. Stain the border of the table top, the back of the table, and the legs with walnut gel stain. Use a soft, lint-free paper towel or cloth for application, rubbing away the excess with a clean area of the towel or cloth. If a darker color is desired, rub a light amount of black antiquing gel over the stained wood.

2 With a 1 in. (2.5 cm) brush, base coat the table top inside the stained area with gold acrylic paint. When it is dry, a second coat of paint can be applied.

3 Wet a sponge, wring out the excess water, and dab one side into the light brown gel stain. Pat on a clean area of the palette to remove any excess. With a slightly rolling motion, pat the gel over the painted section. Allow some of the background to show through. Some areas should be slightly darker than others, so while the light brown gel is still wet, add a bit of walnut brown gel stain to the sponge. Do not overdo; much of the light brown gel and the base coat must be visible.

4 Using a gold metallic paint and a script liner, paint the stroke work around the border. This will clean up any irregularity where the "leather" and stain join. With a shader brush and gold metallic paint, trim along the routed edge of the table top and the edges of the table legs. When all areas are dry, finish with a satin brush-on or spray varnish.

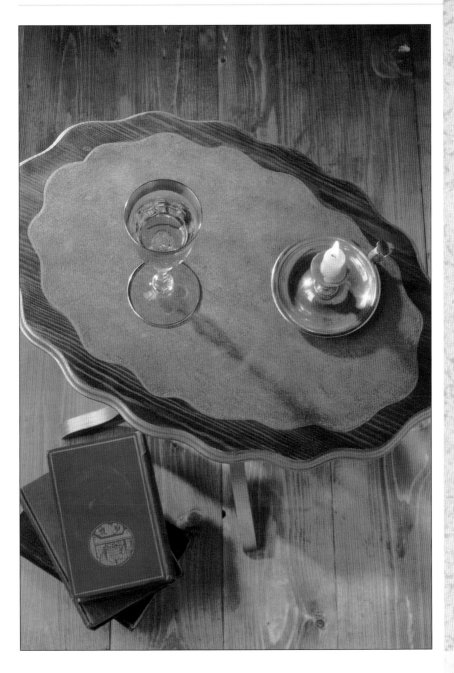

CHAIRS

A chair is a far more complicated piece of equipment than you might think. It not only has to withstand the weight of a human frame, but also survive bad treatment such as rocking back and forth. This means that before you think about finishing a chair, you should check its structural soundness and make any necessary repairs.

A chair can be very complicated to paint and it is advisable to approach it in a well-planned manner. Begin with the chair upside-down and tackle the stretchers and then the legs. Next comes the underside of the seat. At this point the chair can be turned back onto its legs. Check that you have painted all the bits below seat-level before starting on the back, the arms, and finally the seat.

Chairs, like tables, can be treated adventurously. Pickling and liming are popular choices, as are sponging, dragging, graining, and gilding. Much depends on your overall decor – is it period or modern, rural or sophisticated, simple or elaborate?

BELOW: Bold, bright and busy, this craft-style chair would cheer up any kitchen with its checks, stripes, and spots. The back crossbars and the seat have been colorwashed with a strong turquoise acrylic, with a pale yellow border wash around the seat giving the piece a distressed look.

ABOVE: Rubbed antiquing produces a lived-with look that is gentle on the eye and allows the piece to blend into a color scheme more easily.

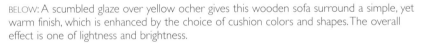

ABOVE: The detailing of this chair back is picked out with liming paste to give a chalky appearance suggestive of years of use.

RIGHT: One thing that time does is cause a surface or varnish to crack. These cracks usually add a certain charm to a piece, making it much more visually interesting. Fortunately, we no longer have to wait for time to provide crackle finishes; we can recreate it, as shown here, using a crackle medium.

BELOW: A scumbled glaze over yellow ocher gives this wooden sofa surround a simple, yet warm finish, which is enhanced by the choice of cushion colors and shapes. The overall effect is one of lightness and brightness.

CABINETS

K itchen cabinets or units, more than any other item of furniture, require protective finishing. Regardless of the paint effect you choose, always finish with several coats of polyurethane varnish. Kitchen units are a popular subject for decorative paint effects, and a successful finish can make all the difference to the appearance of the kitchen. Liming, pickling, dragging, distressing, colorwash, and stenciling are just some of the choices available.

An ordinary non-kitchen cabinet receives less wear and tear, but you still need to think about the demands that will be made upon it and to consider the design. Does it have drawers, doors, or both? How are these fitted to the carcase? Do the drawer fronts stand proud or lie flush with the frame? All these moving parts need to be checked before you start decorating. Before you begin painting, make sure that all moving parts are masked to prevent a build-up of paint that will jam or impede their movements. Never paint the drawer runners as this will impede their smooth operation.

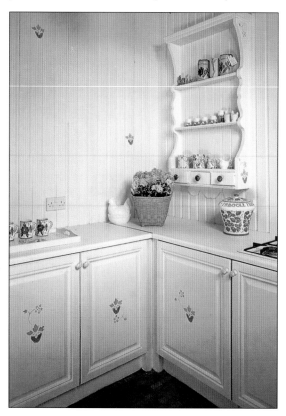

LEFT: Surfaces dragged in clear pale lemon glaze make this Scandinavian-style kitchen appear more spacious. Unadorned, it could be bland or over-cool. But the strawberry stencils provide the simple note that gives the room its charm.

LEFT: The use of the natural stained wood as a background to the folk art-style motif gives this bedside cabinet a rural folk feel. This approach to painted wooden furniture is a tradition that grew in the Alpine regions of Scandinavia and in the American colonies. If the piece to be painted is made from good wood with an interesting grain, utilize it as an interesting background to your design.

ABOVE: This stencilled cabinet, blends with the dragged stripes of the wall, creating a fresh relaxed atmosphere due to its colors and graceful symmetrical patterning. The lines that partially frame the design anchor it to its setting. Without them the design would lack focus.

Accessories

Almost any item for the home can be given a decorative paint treatment. Mirror and picture frames, chests, wastepaper baskets, boxes, clocks – the list is endless. Cheap items, picked up in secondhand stores and sales, can be entirely transformed with clever use of découpage, stenciling, *trompe l'oeil,* and other paint effects.

Smaller items, particularly when you are new to paint effects, are less daunting than major projects such as an entire room or a large piece of furniture. You can feel free to experiment and to learn and, as a result, you can have a great deal of fun for a minimum amount of expenditure.

The pictures in this section show a small sample of decorative accessories, ranging from chests to milk churns, with the aim of encouraging your creativity.

LEFT: These two imposing torchères, or candle-holders, have been painted black and skillfully gilded to give the brilliant but mellow finish appropriate to an antique object.

RIGHT: This colorful folk art Father Christmas will brighten your festive season. Made from wood, it has been painted, antiqued, and then varnished.

Three different treatments for old chests illustrate the diversity of styles achievable with paint. *Trompe l'oeil* gives an illusory peep at a mellowed and non-existent collection of sports equipment; a blanket box has been colorwashed and stenciled in muted colors, then rubbed to emphasize its age; and finally, hand-painted figurative designs have been given an antiqued finish.

HERB CABINET

This attractive lattice-fronted cabinet is just one way to store and display your dried herbs. Either make a cabinet like this or decorate one of your choice. The motifs used here are bay, rosemary, marigold, chive, and borage, but you can choose your own favorites.

1 Using a 2 in. (5 cm) brush, cover the entire cabinet with a primer coat of watered down acrylic white paint, followed by a solid coat of undiluted white acrylic. This will give all the following coats more vibrancy. Allow to dry.

2 With a 2 in. (5 cm) brush, apply one coat of bright yellow acrylic paint to the inside of the cabinet and door.

3 With the same size brush used in Steps 1 and 2, apply one coat of terracotta-colored acrylic paint to the outside of the cabinet, but not the door.

4 Apply one coat of turquoise acrylic paint to the outside of the door and the return. Allow to dry.

5 Apply a layer of acrylic crackle glaze over the turquoise blue area. To achieve larger crackling, apply more glaze; use less glaze for smaller crackling. Allow to dry.

6 Mix up some orange using equal amounts of terracotta and yellow acrylic paints; apply over the blue

glazed area. Take care not to overbrush the paint, so that the glaze is not disturbed. Allow to dry.

7 With a soft cloth, lightly apply some strong, orange artists' acrylic paint over the softer orange area, being careful not to cover the blue exposed in the crackling.

HERB CABINET (continued)

8 With a pencil draw the images to the required size onto tracing paper. Position the trace images on the cabinet and secure with masking tape, so that the image does not move around. Then position the tracing paper underneath, graphite side down. Using a ball-point pen or a medium pencil, trace through the image onto the cabinet.

9 Lightly pencil over the traced image, as the powder will smudge away. With a small pointed brush, paint all the leaves and stems of the herbs with a mid-green paint, working flat shapes up to the outlines. For a little variety of color, add a touch of blue to the bay and rosemary, and a touch of yellow to the marigold leaves.

10 Paint the basic flat flowers, using orange for the marigolds, lilac for the rosemary and chive, and cobalt blue for the borage.

11 Add highlight details in yellow or white to pick out leaf veins, petals, and roots, and shadow details by mixing dark blue with the "base color" to give shape to the leaves, flowers, and stems. Varnish to seal and protect.

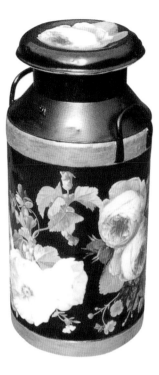

TOP LEFT: A bold découpage in light-filled colors, given depth by the rounded surface and dark ground, assigns this old milk can a new role as a beautiful decorative object.

ABOVE: This arabesque wall sconce is the ideal ground for a verdigris effect, which lends it the characteristic blue-green patina of weather-worn antique metalwork.

LEFT: This oak clock has been stripped and then limed. Oak is particularly suitable for liming because of its open grain.

Gallery

I n this final section you will see some fine examples of
the paint effects that have been described throughout
this book. The artists of yesteryear were masters in
devising finishes that rivaled those of nature. In fact, the
artists became so proficient in their field that today often
the eye of the most experienced artisan is unable to
determine the genuine from the faux. The word faux
(pronounced *fo*) is a French word that means unreal, not
genuine, or phoney.

Many of these imitations have been lovingly preserved
and are still as beautiful as when they were originally
produced. Although it took years of practice for those great
craftsmen to achieve the expertise needed for quality
workmanship, today even the beginning artist can create
fantastic faux-finishes using the products made available by
modern technology.

WOOD FINISHES GALLERY

▲ **DESIGNER BED** Not only is there a craze for painting old pieces but new styles are joining the world of painted wooden furniture. This stylish and unusual bed is an example of the latest in "designer" painted wooden furniture. The sections have been painted in different colors and the 50s-style motif has been applied with silver metal leaf. The inspiration for this design was starlight and the night sky.

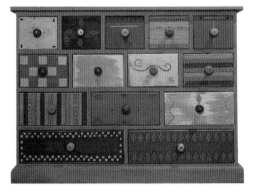

◀ **MULTIDRAWER, MULTICOLORED CHEST** This chest has been given a loud and proud new image by using every primary color available and a different design on each drawer. Even the knobs on each drawer have been painted in a contrasting bright color to the drawer design. The finished piece has a vibrant patchwork quilt look to it.

◀ **WOODEN BOX** Cherry and walnut gel stains were rubbed into the sanded, raw wood box. Masking tape was used to create a pattern for areas to be stained or painted, and to cover areas that were not stained.

◀ **PICKLED OAK BOX** Many hardwoods used to be treated with lime to protect them from destructive pests that ravaged buildings and furniture. However, the familiar white grain of treated wood has now become popular, and can be achieved easily with pickling wax. A layer of pickling wax was applied to this box with steel wool. When dry, a little clear furniture wax was added, and then buffed to a mid-sheen finish with a soft cloth.

▼ **VOYSEY-INSPIRED SIDEBOARD** This 1905 sideboard has been carefully painted using colors and motifs of the era when the piece was originally made. The motif was copied from an original design by Charles F. Annesley Voysey (1857–1941), who was an important architect, furniture, and fabric designer and a leading figure of the arts and crafts movement. The rubbed-back two-color paint finish and the blistered paint technique on the panels give the piece an aged look.

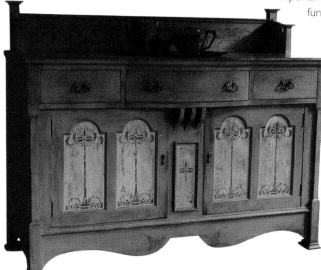

◄ **CARVER CHAIR** This designer chair has modern and classic influences in its design and shape. It has been painted in a mixture of flat, bright modern colors in some areas, and a distressed finish has been applied to some of the more classical shapes on the piece, again using strong 90s tones. The unusual arms on the chair have been given a leopardlike motif, which gives their exaggerated shape a pawlike quality.

▶ **PALE CREAM FLORAL WARDROBE** This very attractive design has a clean, fresh pale but distressed background treatment on the wood, giving the piece a neutral but interesting starting point. These traditional-style motifs of flowers have been organized in a modern way, like randomly placed ceramic tiles.

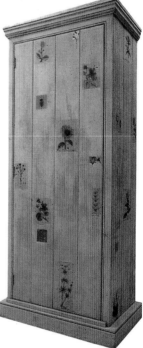

◄ **CRAQUELURED FLORAL TABLE** This plain two-tiered table has been given more interest with a coat of bright yellow paint, a detailed floral border around the top tier, and a finishing craquelured varnish. As the name suggests, craquelure is a traditional French product, and is a transparent varnish that is designed to craze when drying. Some stainer is rubbed into the dry craquelured varnish to bring out all the detailed cracking, providing an interesting aged finish to the underlying artwork.

▲ WOODEN SCREEN BY CONZALO GOROSTIAGA

This wooden screen has been painted in a *trompe-l'oeil* manner. Clever use of light and shade in the fabric folds, and coloring that echoes and enriches that of the background, draws the eye to admire the effect itself rather than simply seeking to deceive it.

METAL FINISHES GALLERY

▼ BACKGAMMON BOARD

The simple paint effect shown here can be used to transform any household object or faded decorative piece. In this case, an old, discarded knife-and-fork case was turned into an attractive backgammon board. The weathered finish was achieved by applying black gloss to a terracotta base paint, using a cloth or tissue. A gold and bronze wax rub was then applied lightly to highlight the playing positions and to enhance the natural texture in the grain of the wood.

MIRROR FRAME BY CAMILLA J. H. REDFERN

This ornate mirror frame has been gilded and gently antiqued using a raw umber glaze. The patina of age gives the piece greater weight and style and will add elegance to any room.

◀ CRACKLE FINISHED PLATE

The crackle finish on this serving
plate was accomplished by base
coating the sealed surface with
gold metallic acrylic paint,
applying crackle medium in
crisscross strokes, and then a
top coat of red acrylic paint.

▶ VERDIGRIS PLATE

The natural corrosion of
most metals containing
copper produces a very
distinctive blue-green patina
known as verdigris. You can
imitate this effect on most surfaces
with paints. Here a base coat of
turquoise acrylic paint was applied first and
then a coat of gold metallic paint. Then the surface was distressed to allow the
turquoise paint to show through.

◀ GILDED JEWELRY BOX

This jewelry box has been decorated
by adding shells and string with craft
glue, and then finished with paint. The
box was base coated with acrylic
paint. When dry, gold paint was
brushed lightly over the surface.

MARBLE, STONE, AND SHELL FINISHES GALLERY

▶ **CANDLE BOX** A combination of techniques has been used on this candle box. After base coating, the lid and plinth were marbled. Decorative stroke work and trim were added with gold metallic acrylic paint. A floral picture, découpaged in the insert, and a coat of varnish were used to complete the project.

▶ **MARBLED PLASTER BUST**
This marbled plaster bust is finished in a grey-marble effect to imitate a grand sculpture from an earlier age. When imitating marble, it is always useful to have either a real sample or a photograph of the original.

▲ **STONE-EFFECT PICTURE FRAMES** Try using natural objects such as shells to enhance stone paint effects. These frames were base coated with cream acrylic paint on the right and peach acrylic paint on the left. Diluted gold paint was then brushed lightly over the surface.

▼ **MARBLE ENTRANCE HALL** The most beautiful combination of black, white and green marbles on different surfaces has created a very stylish, crisp and smart feel to this entrance foyer. It is quite simple yet open and inviting.

DECORATIVE FINISHES GALLERY

◀ **PAPER LAMP** This unusual, asymmetrical lamp was made using air-drying clay and sculptor's mesh. Three shades of blue tissue paper and beaded-texture gel were used to decorate the base and shade of the uplighter. Tissue paper was torn into strips and applied to the mesh using diluted craft glue. The texture gel was applied to the lamp base and graduated up the sides of the shade. Once dry, random areas of the textured base were highlighted using white and blue acrylic paint brushed lightly over the surface with a dry, flash brush.

▶ **TEXTURED BOWL** This decorated bowl was created by moulding air-drying clay around a glass cooking bowl. Once dry, the mould was removed and primed using a coat of craft glue painted over the surface. Texture was created in the paint before application by mixing rough-grain sand and craft glue with the turquoise acrylic paint. The mixture was applied thickly with a spatula. Once the surface was covered, random squares were painted around the sides of the bowl using white acrylic paint. While the paint was still wet, lengths of shaped copper wire were pushed in around the squares to create a stitched effect.

▸ **SPIRAL BOWL** This papier-mâché bowl has been decorated by adding wire spirals and then a paint finish. Once the spirals were attached, the interior was painted using acrylic paint blended with craft glue. Yellow highlights were added to the rim and base, and when dry, red acrylic paint was lightly sponged over the surface.

◂ **PAPIER-MÂCHÉ VASE** This vase was made with a mixture of layered and pulped papier-mâché on a contoured vase as a mould. A layering method was used to create the vase shape, and the pulp was added to embellish it by building up raised areas. The texture of the pulped papier-mâché was enhanced by the paint effect. A base color of blue acrylic paint mixed with a little craft glue was applied. Once dry, a second layer of turquoise acrylic paint was dabbed over random areas using a stencil brush. The texture in the pulp was enhanced by rubbing a small amount of red paint over the surface.

GLOSSARY

Alive
A paint or varnish surface that is still soft, wet, and in a workable state. When it begins to set and becomes tacky, it ceases to be alive.

Base coat
The paint on top of which other layers are applied, as in an undercoat.

Base color
The foundation or background color of a design, sometimes called the ground color. Off-white, for instance, is the base color of white Sicilian marble.

Cissing
An effect created by spattering solvent on a paint or varnish surface before it is dry. Mineral (or white) spirits are usually spattered on oil-based paint, and water on latex, but the method works well the other way around as well.

Crossing off
The final finishing stroke of a paint method. The term is interchangeable with "laying off," except that the latter tends to refer to the whole activity and the direction of the crossing off, whereas crossing off refers to the single action. Crossing off *varnish* means making a stroke at right angles to the rest of the varnish strokes – which are usually vertical – at the bottom of a panel or surface. This stops the varnish from running.

Cross-stroke
A criss-crossing stroke in an "X" formation, usually employed when applying gloss paint, distressing color wash, or for other broken color techniques.

Cutting in
Painting into an angle or onto a narrow surface like a glazing bar. A cutter is a brush of moderate to narrow width with a flat chisel shape or hatchet point.

Diffuser
A T-shaped pair of tubes used by artists to diffuse paint or ink into a very fine spray. The base of the "T" is placed in the liquid; suction is created in the tube by blowing in one arm of the tube, drawing the paint upward, and a second breath disperses the liquid spray from the other arm.

Flatting-oil
A 1:6 mixture of boiled linseed oil and mineral spirits, used to "float" color on.

Gesso
A hard, off-white surface traditionally made from hide glue (usually rabbit skin) and whiting, and often used as base for gilding work. The best is still made this way, and is applied hot, but never boiling, in layers, mostly to picture frames and furniture. A cold, ready-to-use liquid form is also available and is adequate for most decorative work.

Goldsize
A size used in the gilding process. Its clear, viscous quality thickens paint.

Ground
Any surface to which a paint finish is to be applied. The term is also sometimes used to mean the base color; for example, white Sicilian marble has an off-white ground.

Gypsum board
A form of plaster board.

Laying off
Another term for crossing off. With paint, it means the uniform direction of finishing strokes as well as the applications of them; with most types of paint on most surfaces, it should be done toward the light.

Laying on
The initial action of applying paint or varnish, before any finishing strokes. Laying on may be done in any direction unless specified, but should never be treated as a brush method for achieving a finished surface, except when you are distressing a color wash.

Masking tape
A strong, sticky-backed tape used for blocking off surfaces to protect them from paint. It is also suitable for holding other materials, such as paper and polythene, in place.

Molding
Raised relief patterns in wood and plaster. In addition, the parallel raised surfaces of doors and architraves, windows, and ceiling surrounds are also loosely referred to as moldings.

Mottle
An irregular pattern similar to that cast by the

shadows of leaves. The mottles can be of any size from fist to pin-head. A mottling action is a smudgy stipple created by dabbing a brush or sponge up and down, or a spray made from patches from random jets.

Over-brushing
Brushing one color loosely on top of another, either to cover it partly or to alter its tone.

Over-painting
Covering and obliterating one color with another.

Pattern-work
The general structure and flow of a design, as in stenciling, on moldings and lining, or decorative work of any kind.

Plaster board
A sheet of plaster with a stiff paper covering on either side. One side of the board is finished and can be used without further treatment.

Plumb-line
Traditionally, a cord with a lead weight at the bottom. The plumb-line is held steady like a stationary pendulum to test a true vertical.

Pumice
A light, porous, volcanic rock used for polishing and scrubbing. Now usually available in a lump approximately 5 inches (13 cm) across, it should be cut in half (with an old saw as it blunts the teeth) and rubbed on a wet flagstone before use. It is excellent for washing down shiny surfaces. Powdered pumice should be mixed with oil and applied with a piece of thick felt to achieve a smooth finish on paint or varnished surfaces. After using it, the surface should be rubbed with a lint-free cloth and washed in turpentine. Pumice gives a soft, deep gleam.

Retarder
A colorless gel agent mixed with some water-based paints, like acrylics, to slow their drying time by inhibiting evaporation.

Spirit level
A wooden or steel rod with a phial in the center filled with spirit, used for testing a true horizontal. When the bubble in the liquid is in the exact center of the phials, the surface is exactly level.

Steel wool
This is available in many grades from coarse to very fine, and looks like a bundle of gray hair. Used dry, or with water or oil, it is highly effective for rubbing down paintwork, and giving a key or tooth to smooth surfaces such as aluminium or galvanized steel. It is suitable for

removing rust, used in conjunction with mineral spirits. *Don't* use it on surfaces where you intend to apply water-based paint, as embedded particles of it may cause rust under latex. In this case, use bronze wool.

Stippling
Using a sharp, stiff-bristled brush to create a pattern that resembles fine frit, either by exposing a color used under glaze, or by applying one color on top of another.

Straight-edge
A long ruler or any stiff, straight object which offers an undulation-free edge as a guide.

Tack rag
A sticky cloth designed to pick up greasy, gritty particles from a surface.

Template
The master or guide drawing for a design, from which stencils are cut and tracings made.

Tipping off
Touching the tips of brush bristles on the side of a paint kettle to eject excess paint from them.

Translucent color
Color that allows you to see the presence of another beneath, in the manner that gauze allows you to see through it.

T-square
A T-shaped ruler. The right-angled cross-bar is placed against the straight side of a surface, ensuring that a line drawn will be at a right angle to it.

Under-toning
The tones of background colors. A soft ochre mottle applied to marble before the veins and top glazes are applied is under-toning.

Wash
A thinned coat of color applied all over a surface, either over another paint or as a mist coat when latex is applied to new plaster.

Water tension
The ripples caused in water-based paint where patches of it dry at the edges and don't blend into the adjacent patch evenly. This is caused by evaporation from the thin edge of the paint area being faster than that from its center.

Wet-and-dry paper
An abrasive paper designed to smooth a surface with alternate applications of lubricated and dry abrasion.

Wet-edge
The alive edge of a paint area. The wet paint into which the paint of an adjacent area can be harmoniously brushed.

INDEX

PHOTO CREDITS

The material in this book previously appeared in:

The Book of Creative Paint Finishing Techniques; The Encyclopedia of Decorative Paint Effects; Paint Finishes; Paint Effects; The Complete Guide to Wood Finishes; Recipes for Surfaces; Discover Rubber Stamping; The Art & Craft of the Tile; Essential Stencils; 1,200 Paint Effects for the Home Decorator; Painted Wooden Furniture; Fantastic Finishes; The Illustrated Book of Painting Techniques